WINCHESTER
IN
50
BUILDINGS

GARTH GROOMBRIDGE
& KIRSTY KINNAIRD

AMBERLEY

How to Use this Book

The buildings are listed in chronological order by date of construction, which indicate original building dates and any subsequent significant rebuilding. The map enables you to find the buildings within the book as the key uses the same numbers as the text. Before visiting any of the buildings it is advisable to check their websites for opening hours and access.

First published 2018

Amberley Publishing, The Hill, Stroud
Gloucestershire GL5 4EP

www.amberley-books.com

British Library Cataloguing in Publication Data.
A catalogue record for this book is available from the British Library.

ISBN 978 1 4456 7175 8 (print)
ISBN 978 1 4456 7176 5 (ebook)

Origination by Amberley Publishing.
Printed in Great Britain.

Contents

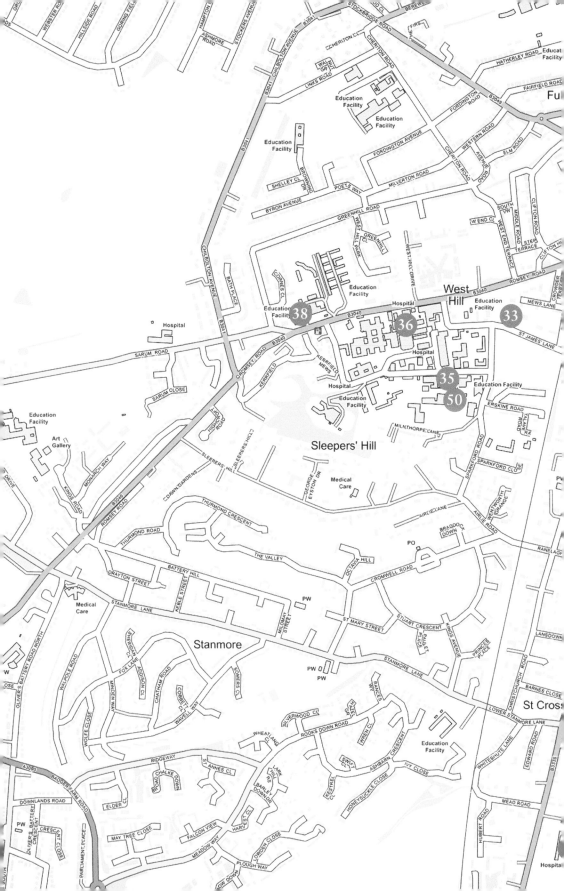

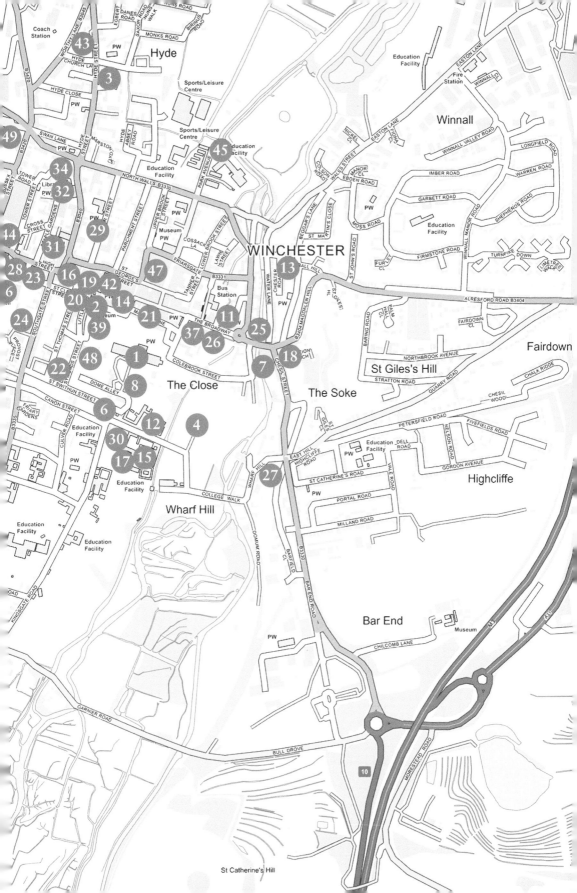

Key

Acknowledgements

Our personal thanks goes to: Professor Elizabeth Stuart for the University of Winchester book, and especially Mark Allen of the University of Winchester (Kirsty's former history lecturer), who kindly gave us a 'conducted tour' of the campus and its buildings; also Mathew Jane, head of the energy and environment department at the University of Winchester. Special thanks to Tom Beaumont James (especially on The Pentice); and to Michael Carden, for extra information and corrections on Pagoda House, as well as confirmation of Colin Stansfield Smith as Record Office architect.

Thanks to Peter Hitchins of Symondsbury Manor, for his own useful recollections of the Pagoda House; to John Stanning, Chairman Keith Leaman (in particular for information about the Refectory/Visitors' Centre); and again Michael Carden of the City of Winchester Trust, for their time, patience and interesting information.

Thanks to Debbie Stokes and Helen Muir-Davies of Winchester College for their help and cooperation, very much appreciated; to Andrea Thomas, for her excellent private 'conducted tour'; and to College Archivist Suzanne Foster, for corrections and suggestions.

Thanks to Julie Winks, Deputy Clerk to the Trustees, for her comments and corrections of the St Cross text; Lieutenant Colonel Colin Bulleid at the Serle's House Royal Hampshire Regimental Museum, for help and correction of text; also to Andy Spencer, David Campbell and especially Ken White of the Masonic Centre, for a detailed history of the former Masonic temple (now WHSmith).

Thanks to Ross Turle from the Hampshire Cultural Trust for information on the City Museum; Martin Smith, of St Denys Church, Portswood, concerning Garth's enquiries of the St Maurice Church organ (for further information visit www.stdenys.com/st-denys-church-organ/ for a possible association with Handel).

Thanks to Jenny at the Discovery Centre for letting Garth have a copy of *150 Years of Library Service in Winchester* by Ray Helliwell and Geoff Salter (Hampshire County Council, 2001). Thanks to Debbie Williams, assistant manager at Boots, and Jenny Horn, assistant manager at Lloyds Bank, and to Peter Judge, Lloyds Group Archivist. Thanks also to Rachael Alexander of The Colour Factory, receptionist Fiona Ryan, Chief WSA Librarian Catherine Polley and Dan Boyce, for information on the Winchester School of Art.

Thanks to the various helpful staff at The Pentice shops (The White Company, Jeremy French, Spacenk, and Marsha at Montezuma's Chocolates); the staff at the County Records Office, in particular Jane Harris and Adam; Marion Widdop and Emma Backs of the Lido, who showed Garth around on a recent Open Day; also Sophie of 'Copper Joe's', and Ian Bailey, curator of the AGC Museum, and his colleagues for their review of our text. Finally, we would like to thank David Nicolson, owner of The Black Boy pub for his time and assistance.

All photographs were taken by Garth Groombridge and/or Kirsty Kinnaird, and are their copyright. All opinions and comments expressed, and any unintended errors within

Kirsty Kinnaird outside the Colour Factory, Gordon Road, in 2017.

the text, are entirely those of the authors. We appreciate that there are numerous interesting and historic buildings in Winchester; inevitable we had to omit so many, but this was our choice.

Finally, a word on Thomas Stopher; architect, builder and businessman in Winchester. What is not always clarified elsewhere is that there were *two* individuals of this name – father and son. Thomas senior was born around 1802 and moved to Winchester in 1839. He died in December 1874, aged seventy-two. His son, Thomas, was born in 1837 and died in 1926, aged eighty-eight. He married three times: in 1861 to Mary Frances Counter Hendry (*c.* 1836–1876), by whom he had a number of children; secondly, in 1877, to Louisa Baker Brown (*c.* 1829–1899); and lastly, in 1900, to Edith Louise Stabbs (1869–1957), by whom he had a daughter. We have, therefore, in our text attempted to identify which Thomas is which.

Introduction

Winchester has a long and magnificent pedigree, at times second only to London in its importance to the narrative of English history. Once at the centre of a configuration of strategic Iron Age hillforts (later the Roman Venta Belgarum; later still, as Wintan-ceastre, the Saxon capital of the Kingdom of Wessex under King Alfred), it was created a cathedral city as early as the 660s, thereafter destined to become one of the most powerful temporal and spiritual ecclesiastical bishoprics in medieval England. Prior to the Reformation, it was an important shrine to local saint St Swithun, and a major monastic centre comprising St Swithun's Priory, the Nunnaminster and Hyde Abbey, together with the Christian-inspired Hospital/Almshouses of St Cross and St John's (both of great antiquity), and later seventeenth-century foundation of Christ's Hospital. These last three institutions have survived on into the twenty-first century, while the administration of the ancient cathedral passed from Priory to Anglican Dean and Chapter.

Forever associated with Alfred the Great, the city continued to have regal connections right up until the reign of Charles II, and a 900-year-plus military presence from William I until the 1980s. Throughout that time the site of William's castle has been at the heart of both regional governance and the maintenance of law, again since the eleventh century. Even now, the current 1970s Crown Court on Castle Hill is second only in importance to the Old Bailey in London. At the time of writing both the mid-Victorian Royal County Hospital and the County Prison are still located on Romsey Road, although the Hampshire County Police Headquarters has recently relocated to Southampton.

Winchester College has been a much-respected academic centre since the fourteenth century, while the city's educational status was further enhanced by several education foundations from the nineteenth century that have since evolved into the University of Winchester and the Winchester School of Art. Winchester's civic importance was re-established with the Victorian grandeur of the Guildhall followed by the neo-Gothic Hampshire County Council offices on Castle Hill and, in the 1960s–70s, by Queen Elizabeth II Court, opposite Westgate. For over a millennium the city's wealth and commercial fortune waxed and waned with the medieval wool and textile trade and important annual fairs; then the arrival of the Itchen Navigation (transporting coal and salt), then the railways, and most recently the M3.

Last, but not least, the city is a centre of culture and entertainment, with the Theatre Royal, the Hat Fair, connections to Jane Austen, ancient pubs, a few still surviving independent bookshops, a number of significant military and civic museums, as well as its own dedicated County Records Office.

This book is a labour of love devoted to one of the most important and fascinating cities in the country. The greatest difficulty has been to select *just* fifty buildings out of so many candidates. However, our ultimate goal has been to step off the well-trodden path of local history books and, where possible, seek out new or rarely recorded facts, while sometimes correcting or challenging others.

The 50 Buildings

Despite its origins in antiquity as Roman Venta Belgarum (*c.* AD 70), and its status as chief city of the Anglo-Saxon Kingdom of Wessex, the Winchester we see today is essentially post-Norman Conquest, the two great buildings from the eleventh and twelfth centuries being the castle and cathedral. Of these, only the Norman Cathedral now remains, with many of the medieval buildings which once surrounded it now gone. Predating this was the original Saxon palace chapel from around 642–643, built by King Cenwalh (reigned *c.* 642–645, and *c.* 648–672). Next was the Old Minster, built in 662 by Bishop Hedda, with the creation of the diocese of Wintancestir, as it was then known. The body of the Anglo-Saxon bishop Swithun (*c.* 800–862), later the city's patron saint, was moved here in 971, but by then work on the adjacent New Minster had begun (in 901). The two buildings were so close it was said that their respective choral music intermingled 'with chaotic results'. In 1070 the last Saxon bishop Stiyand was replaced by William's royal chaplain, Walkelin, and a new cathedral, dedicated to the Holy Trinity, was began in 1079; the first stage was completed in 1093, when the Old Minster was demolished. Following excavation in the 1960s, its outline can be seen laid out in brick on the Cathedral Green. The crypt, transepts and basic structure of the nave belong to this period, although the original crossing-tower collapsed in 1107, replaced by the tower we see today. The nave was remodelled, the twin towers removed and the West Front constructed under bishops Edington (1346–66) and Wykeham (1367–1404) in the Perpendicular English Gothic style, and further alterations and additions continued throughout the fifteenth century.

With Henry VIII's Dissolution of the Monasteries, the Priory of St Swithun, the monastic buildings, cloister and chapter house on the south side were demolished, and even the church itself threatened. A greater threat came at the beginning of the twentieth century. The east end, beyond the old Saxon Minster, had been built on chalk, lime and peat over the river gravel, and now, as cracks appeared, the entire structure was in imminent danger of collapse. In 1905–12 major restoration was carried out under Diocese architect Thomas G. Jackson and consulting engineer Francis Fox, together with one of the most experienced divers of that time, William Walker (born William Robert Bellenie, 1869–1918, he later adopted the name Walker), employee of Siebe Gorman Ltd. Between 1906 and 1911, six hours a day, five days a week, Walker worked away in a bulky diving suit weighing 200 lbs, in darkness and at a depth of 18–20 ft of sediment-filled water, to lay 115,000 concrete blocks and 900,000 bricks, using 25,000 bags of concrete needed to save the cathedral. The original estimated cost of £20,000 escalated to £113,000, much of which was raised by funds and public support. Walker, a true working-class hero who died during the Spanish influenza pandemic, was made a Member of the Royal Victorian Order (MVO), and later honoured by a statue and annual prayers in the cathedral, while more recently the former Old Market Inn (*c.* 1860, the Square) has been renamed after him, complete with appropriate memorabilia.

The crypt (which has featured Anthony Gormley's mysterious statue *Sound II* since 1986) still floods following heavy rains. At 554 ft Winchester Cathedral is the longest

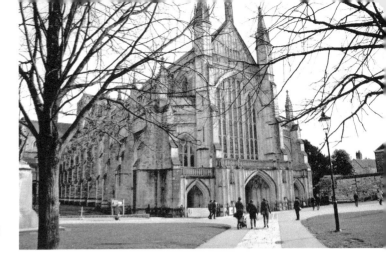

Cathedral Church of the Holy Trinity: the West Front viewed from Cathedral Yard.

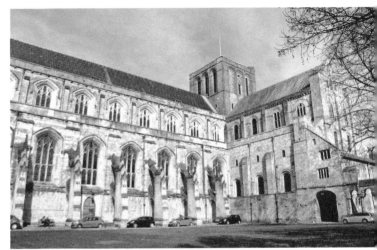

Cathedral Church of the Holy Trinity: the south side as seen from Cathedral Close.

medieval cathedral in the world, although the height is only 78 ft. The flying buttresses only dates from 1909–12, reinforcing the south nave wall which was weakened by the removal of the cloister in the 1560s.

2. St Lawrence Church

Almost unnoticed on the left as visitors progress from the City Cross (or Buttercross) through the medieval archway into Great Minster Street and the Square is the tiny Norman church of St Lawrence, of which only a doorway wall and the square castellated west tower are visible. While reputed to be the site of an earlier Saxon church, it was subsequently swallowed up by the expansion of the Royal Palace precinct by William the Conqueror, becoming the Chapel Royal, probably enlarged and reconstructed with a chancel in 1449. The tower roof was repaired in 1680 and a side-gallery installed in 1765, later removed in the nineteenth century. Between *c.* 1645 and 1672 its ecclesiastical furnishings were removed and it was used as a school. Much of the current interior dates from restorations made after a serious fire in 1978, and it was re-dedicated in 1980. Originally there were five bells, the oldest dating from 1621, and once used to announce curfew or public executions, formerly held in the Square. Only one now survives. A medieval undercroft extends under

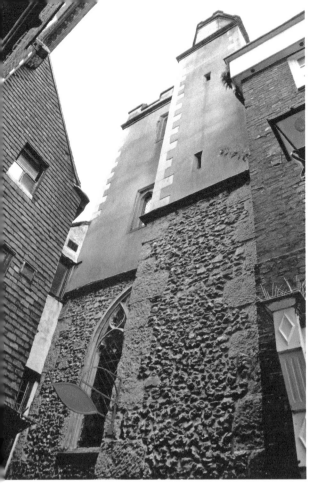

Left: St Lawrence Church from Great Minster Street.

Below: The interior of St Lawrence Church.

the shop two doors along (Gilbert's Bookshop from 1904–95, now Pure Home Lifestyle). The church is named after St Lawrence (or Laurentius), martyred in Rome in AD 258.

Once the site of the old Roman Forum, in Saxon and early Norman times what is now the Square became part of the Royal Palace (later demolished and its stones recycled). It then became a place of gathering, commerce and merry-making, but also of execution, perhaps the most notorious being that of Dame Alicia (Alice) Lisle, sentenced to death by the notorious Judge George Jeffreys in 1685 following the failed Monmouth Rebellion against James II. This grisly beheading of an elderly and much respected lady took place in front of what is now (since 1925) The Eclipse Inn. This building dates from around 1540, and has at various times been a private house, the rectory to St Lawrence, an alehouse, and finally a public house since 1890.

3. Hyde Abbey Gateway and the Parish Church of St Bartholomew

Hyde Street runs north of the junction with Jewry Street, City Road and North Walls, and few visitors or even many residents venture along it; yet hidden here was one of the most significant sites in English history and once a place of great patriotic pilgrimage.

In 1109 Henry I (1068–1135, fourth son of William I, king from 1100) had the New Minster removed to Hyde Mead, just north of the city walls, and a new abbey church was consecrated in 1110. The bones of King Alfred, his wife Ealhswith of Mercia, and son Edward the Elder were interned before the high altar. The abbey was burnt down during the wars between Stephen and Empress Matilda in 1141, and reconstruction of the church did not commence until 1196, with funds still being sought towards its completion into the fourteenth century. Despite being a popular pilgrimage destination, the abbey was inflicted with problems: visitations of the Black Death, and squabbles with both the bishops and city Corporation, and their own tenants. There was another serious fire in 1445. Finally, the year 1539 saw its Dissolution by Henry VIII, and even by 1542 (when the antiquarian John Leland visited) it was being disassembled and looted for valuables and building materials, the stone alone estimated at 50,000 tons. The land passed to Henry's scheming commissioner, Thomas Wriothesley (1505–1550, later 1st Earl of Southampton), and then in 1546 to Richard Bethell (1489–1570), who built a grand house on the abbey site in 1570, now Old Hyde House. While the eastern area about the stream reverted to grazing meadows, the choir end of the church where Alfred and his family were buried initially remained ignored and undisturbed. However, William Cobbett, visiting Winchester with his son in around 1830, was mortified to discover that where once the abbey had been, was now the site of a county bridewell, originally established in 1788. Ownership had descended from Anne Mynne in 1650 to Thomas Knight in 1767, but on his death (1781), his son, also Thomas, had sold the site to the county in 1785. The presence of this institution saw what might be called the second desecration, almost equal to that of the Dissolution, when the convicts – whilst digging the foundations – discovered and broke open the stone coffins, believed to be that of the Saxon royal family, stealing and selling the lead-lining, and wantonly scattering the bones. While some believe the remains were later reburied in the parish church of St Bartholomew, historians and archaeologists are still seeking them, with excavations being undertaken as recently as 2016.

Little now remains of the great abbey except a twelfth-century arch over the millstream, and the gateway, angled north-east by north, once the entrance between the inner and

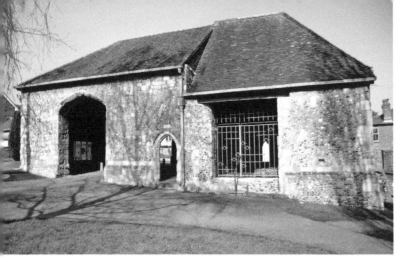

Hyde Abbey gateway in Hyde Street.

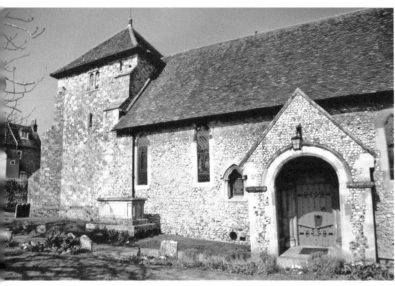

Hyde Abbey,
St Bartholomew's Church.

outer precincts, dating from the fifteenth century, but incorporating older masonry, while adjoining it is a medieval-period stone barn. This was later part of Abbott's Barton Farm, formerly also the abbey lands, which had been inherited by Edward Austen Knight, Jane Austen's brother (the younger Thomas Knight's adopted heir; he took the surname when widow Mrs Knight died), before he, in turn, sold it in 1811 to William Simmonds, 'St Cross farmer', for the sum of £33,670. *His* son was William Barrow Simmonds (1820–1911, Conservative MP 1865–80), who presented the abbey remains to the city to be preserved. He also built Abbott's Barton House, on the Worthy Road, the old Roman road to Silchester.

While the church of St Bartholomew was originally built for the abbey servants, and parts of the structure are Norman (the south porch doorway is *c.* 1130), the church was extensively rebuilt around 1856–62 by John Colson, and again in 1979–80. This is a very attractive building which belies its extensive Victorian- and twentieth-century restorations, and the square (west) tower with pyramidal roof is characteristic of many Winchester churches.

4. Wolvesey Palace

Wolvesey, or 'Wulf's Island', located between the two streams of the River Itchen, was the chosen site for this twelfth-century castle, once a place of almost regal splendour and ecclesiastical beauty, residence of some of England's most powerful bishops during the medieval period who were virtually feudal lords, temporal as well as spiritual. Both protected and confined by the old Roman (later Anglo-Saxon) city walls to the south and east, the cathedral/Minster lands to the west, and Nunnaminster/St Mary's Abbey on the north, this corner of the city had been established as the bishop's residence as early as the tenth century. However, the ruins we see today are from the fortified palace built by two great bishops, William Giffard (1100–29, who built Westminster Hall, in addition to Wolvesey West Hall) and Henry de Blois (1129–71), born around 1090, son of Count Stephen of Blois and Adela, youngest daughter of William I and brother to King Stephen, whose civil war with Empress Matilda wrought such destruction upon the city in 1141. Henry therefore had a combination of pedigree, enormous wealth, good education and great ambition, as well as being a canny administrator, artistic patron, friend to the poor, and prolific master builder (this was influenced by his interest in classical antiquity, following travels to Rome). In 1135–38 he built the East Hall, the Winchester Annals recording, 'in this year Bishop Henry created a house like a palace with a strong tower.' In the aftermath of the Civil War he commissioned a major survey of Winchester in 1148. With the new king Henry II (Matilda's son) enthroned in 1154, and a brief exile (1155–58), Henry's political influence declined, although he still commanded power within the Church. Wolvesey continued to hold the treasury for the estates of Hampshire, Surrey and the Isle

Wymond's Tower.

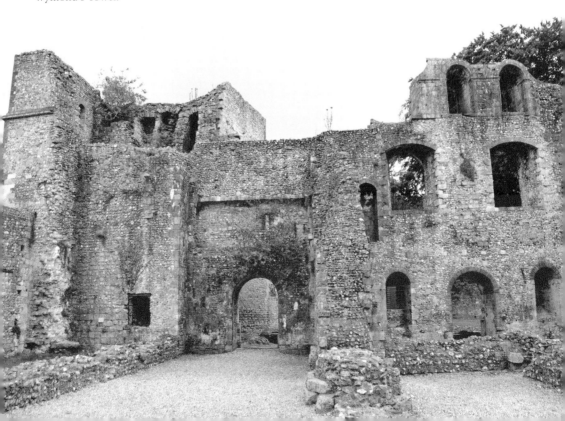

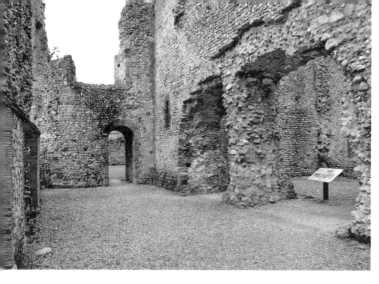

Wolvesey Palace – the ruins of Wymond's Tower (built *c.* 1138–54).

of Wight, and in 1301–2 it was noted that the estates had made a total profit of £5,188 (over £2 million in today's money). Further works (both repair and improvements) were undertaken in 1372–73 by Bishop William of Wykeham (1366–1404, the College founder).

During the medieval and early Renaissance period the palace saw many royal visitors: Henry IV in 1402, who enjoyed a feast here before he married Joan of Navarre; Henry V, who entertained French ambassadors here before the Battle of Agincourt; and Mary Tudor, who stayed here at the time of her marriage to Philip of Spain in 1554. Following the English Civil War, Bishop Brian Duppa began rebuilding Wolvesey (work continued by his successor George Morley (1598–1684, Bishop from 1660), pillaging the medieval building for materials and spending £4,000 on a new palace (the Baroque Palace), started in 1684 and completed by Jonathan Trelawney in 1715. This house too fell into disrepair after 1786 when Bishop Brownlow North decided to demolish much of the Baroque Palace, favouring Farnham Castle as his new residence. The west wing survived and was used mostly for academic purposes – in 1847–62 by the Diocesan Training College, or Winchester College as additional classrooms – and as a museum for stuffed birds. Finally, in 1895, it reverted back into ecclesiastical hands, and after extensive repairs was inhabited again by the Bishop of Winchester, following division of the diocese in 1928. The Old Palace ruins were Grade I listed in 1950, and are now under English Heritage guardianship.

5. The Hospital of St Cross and Almshouse of Noble Poverty

Founded between 1132 and 1136 by Bishop Henry de Blois, this hospital (in the traditional meaning as hospice or almshouse) was built during the civil unrest between Stephen and Matilda in the twelfth century, and was created as a sanctuary for thirteen poor men. In addition it established the tradition to provide a daily meal for 100 suffering men, and in 1889 this became known as the 'Daily Dole' (in early medieval days it was called the 'Wayfarers' Dole'). Two gallons of beer and two loaves of bread would be divided into thirty-two portions for those deemed most needy. Even today, any weary traveller who visits during opening hours and knocks on the Porter's Lodge Shop door will still be offered a cup of beer and a piece of bread. For the tourist, however, the Hundred Men's Hall (now a tearoom) is on the left as you enter through the sixteenth-century outer gatehouse from Back Street.

Once through the Beaufort Tower gate (*c.* 1450; incorporating the original Tower of
John de Campeden, 1383–1410) into the larger Inner Quadrangle, on the west side can
be seen the tall distinctive chimneys of the private quarters of the twenty-five elderly
'Brothers'; seventeen brethren of the original Foundation and eight of the later Noble
Poverty Foundation, still under the care of 'The Master'. They are single, widowed or
divorced men over retirement age, and they wear gowns of fifteenth-century origins, the
original foundation wearing a black gown with a silver cross and the later foundation
wearing cardinal red gowns with a silver cardinal's hat badge, which is passed to a new
brother on the death of the last.

During the medieval period their housing was unique, as each resident had his own
latrine. A corresponding range on the south side was demolished in 1789. The fourteenth-
century Brethren's Hall and kitchens on the north side were built with high ceilings to allow
the smoke and heat to rise above the people working and eating there. Almost certainly the

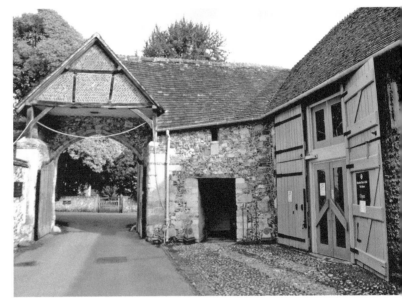

The Hospital of St Cross:
view of gateway to
Back Street.

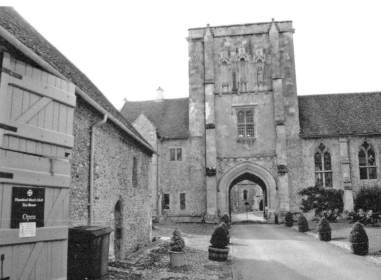

The Hospital of St Cross,
with Hundred Men
Hall (on the left) and
Beaufort Gate.

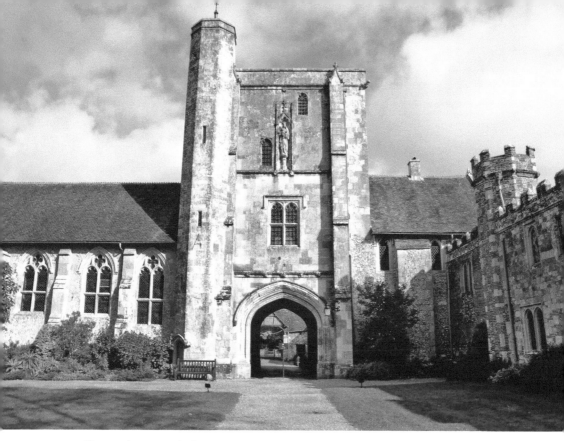

Above: The Hospital of St Cross: Beaufort Gate from the Inner Quadrangle.

Below: The Hospital of St Cross: the church viewed from the gardens.

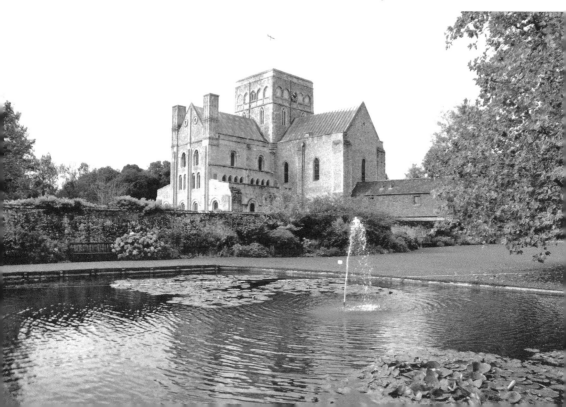

original windows would have had no glass. The meat would have been protected by two metal shutters to prevent it being pilfered; a problem that is sadly still with us today, a number of precious artefacts having been defaced or stolen. Even the long-serving Master, the Revd Francis North, 6th Earl of Guildford (1772–1861), indulged himself at the expense of the hospital, carrying out deceitful deeds and fraudulence so that St Cross had to sell off most of its lands in the Court of Chancery to meet costs and just survived into the second half of the nineteenth century.

Construction of the church (described as being like 'a miniature cathedral') began around 1158 and continued through the thirteenth century; the oldest part is now by the Choir, although this was much restored by William Butterfield in the 1860s. The tower was rebuilt in 1383–85 by John de Campeden, whose painted ceiling (actually the belfry floor) was repainted in 1865. The tower recently underwent restoration. Most of the stained-glass windows date from the nineteenth/early twentieth century. The sixteenth-century long galley leads into an attractive garden with fountains and large pond. The Hospital of St Cross is said to be the oldest continually inhabited almshouse in England and is Grade I listed.

6. Kingsgate and St Swithun's-upon-Kingsgate

Westgate and Kingsgate are the only two medieval Winchester city gates to survive. The latter, first recorded in 1148, is now on the southern flank of the Cathedral Close, possibly on, or at least near to, the site of the original Roman south city gate. This was also the original entrance to the Royal Palace before the Cathedral Close was enclosed in the sixteenth century. The gate we see today, with its vehicular entrance leading into College

Kingsgate, viewed from College Street, *c.* 2014. The modern building on the left was demolished in 2017.

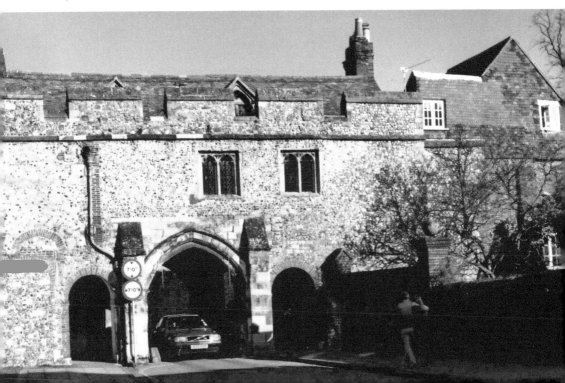

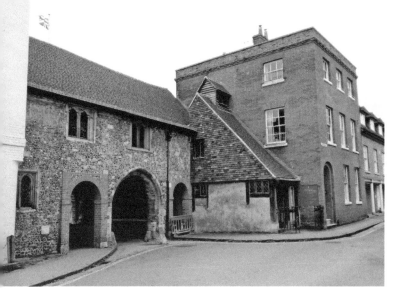

Kingsgate, viewed from St Swithun's Street.

Street and Kingsgate Street, dates from the early fourteenth century, the pedestrian access being added in the 1700s. Until the mid-1930s, when they were demolished, a number of houses and shops extended south from the gate out along College Street, but this had already been remodelled into a small public garden before the Second World War. Built beneath the gate is a rather charming shop, formerly a residential house added in the nineteenth century. Incorporated over the gate is the tiny church of St Swithun-upon-Kingsgate, accessed by a flight of timber stairs from St Swithun Street (dating *c.* 1500), above which the exterior bellcote is now smaller than a hundred years ago. Such medieval gate-churches were once more common, used for prayer by pilgrims and royal visitors alike, to take Mass before entering the city, or travellers setting out on what could be dangerous journeys.

This little church was first mentioned in 1264 when the gate were severely damaged by fire, following a dispute between the citizens of Winchester and the monks of St Swithun Priory. Later the church was most likely used as a chapel for laity who worked for the abbey, although it was also used as the home of the porter, Robert Allen and his wife, in the seventeenth century, 'who did and doth keep swine at ye ende of the Chapell'! It also featured in Anthony Trollope's 1855 novel *The Warden*. The interior is simple but moving, with limewashed plaster walls, oak crossbeams and angled roof supports. The east wall window contains fourteenth/fifteenth-century glass taken from St Peter's Church in Chesil, while alongside is an empty niche which most likely held the statue of St Swithun, which was destroyed during the Reformation.

7. Chesil Theatre

The earliest reference to this site is in the Domesday Book as St Denis Priory, founded by Henry I in 1124, although it was not until 1148 that St Denis acquired a chapel to provide for the Soke residents, mostly cloth-makers, brewers and tanners. By 1282 this church was styled as 'St Peter's-without-Eastgate', eventually gaining more significance in 1515, when combined with St John the Baptist-in-the-Soke.

The unusual design of a square south-east corner with tower, chancel, nave and south aisle could have been due to the confined site; the old Portchester road one side and the River Itchen (prone to flooding) behind. It is probable that there was originally a north aisle,

perhaps pulled down to build the Elizabethan Soke House. The main door is late-thirteenth century and the wall-niche (now in the bar, with a statue of St Peter, donated by builder and local politician Thomas Stopher the Younger in 1895) being mid-fourteenth century.

Following the Reformation, the Soke suffered famine and unemployment. It was not until 1643 that much-needed repairs were made, assisted by a £200 gift from Mr Thomas Hardy, a London goldsmith. In 1783 a small staircase was added, giving access to a wooden gallery about the north wall. However, in the words of the *Hampshire Chronicle*, these changes 'made the place hideous'. In 1895 the church saw its greatest repairs yet, when Thomas Stopher and builder Mr Barnard of Alresford completely gutted and reconstructed the interior at the cost of £700, the church being closed for five months. However, with the opening of All Saints' Church in Petersfield Road in 1891, attendance declined from its peak of forty years' previous.

The twentieth century saw a succession of disasters, from the theft of silver plate in 1921 to structural issues with the roof and east wall. Only a 1925 petition by Mrs Bligh of Kingsland House averted closure, but, following the movement of heavy military vehicles along Chesil Street during the Second World War, in 1948 the masonry in the east wall gave way during a service, and on 2 January 1949 the church closed for good. Subsequent proposals varied from moving it to a new location in Stanmore, to using it as the Red Cross Headquarters or lecture hall, but in 1960 the building was declared structurally unsafe. In 1961 the flourishing, but homeless, Winchester Dramatic Society managed to raise £10,000, and in 1962 work began to create their 'Little Theatre' from the church ruins, all valuable items having been stripped out during the 1950s. With additional financial help from the City Council, the Society

St Peter's Church, now Chesil Theatre, looking north.

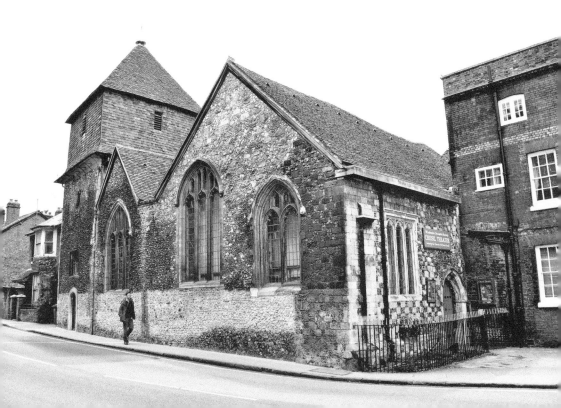

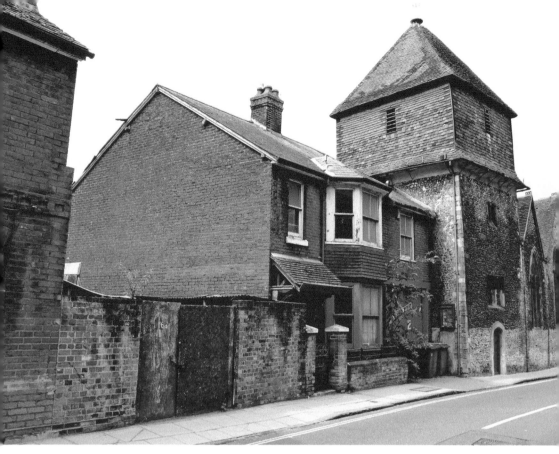

St Peter's Church (now Chesil Theatre) in Chesil Street, looking south.

was able to add a balcony, thereby increasing seating capacity to 130. The theatre officially opened in October 1966. At the time of writing it continues to be the Society's home, but with the following regulations set by the vicar of All Saints' Church; '[that they] will not... hold political meetings...nor perform unsuitable plays to which the Bishop objects'.

8. The Deanery and Prior's Hall, Cathedral Close

Henry VIII's Dissolution of the Monasteries was to have the most profound and long-lasting effect on Winchester. While the cathedral survived, the ancient Benedictine Priory of St Swithun did not, and its abrupt demise in 1538 was to dramatically transform the architectural landscape between Cathedral Yard and Kingsgate. William Kingsmill (who had taken the monastic surname of Basyng, after his home town) was both the last Prior and first Dean, and the period 1539–42 saw the Priory dissolved and remodelled into a dean and chapter. Under this new Protestant Order, St Swithun's shrine was destroyed and the cloister on the south side of the cathedral demolished, along with most of the buildings on the remaining three sides. In retrospect this was the beginning of the transition into the modern world. The Cathedral Close we see today is more of the seventeenth and eighteenth century rather than the fifteenth – more like Salisbury or Canterbury, open and inclusive, rather than closed-in, monastic and insular, exclusive to what was never more than seventy monks (and sometimes as few as forty).

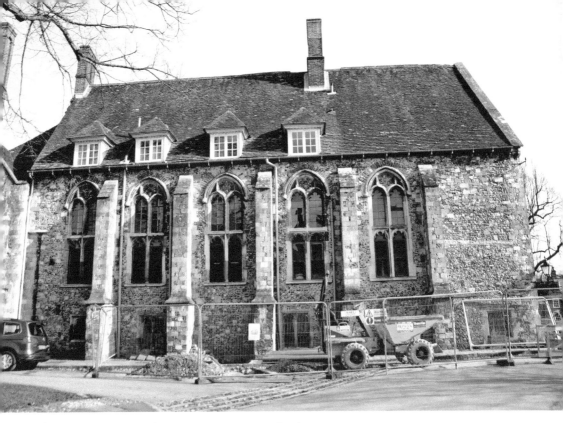

Above: The Deanery undergoing extensive renovation in 2017.

Below: The Deanery, loggia entrance and second-hand bookshop, *c*. 2015.

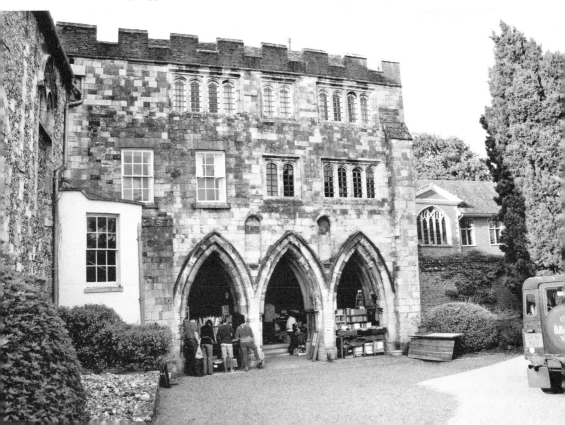

While the original Chapter House was lost, leaving only the Norman arches and columns, new buildings appeared, like No. 1 The Close (dating from 1699, this was the former Cathedral Office and is now a private residence); No. 9, Church House (early seventeenth century, now the Diocesan Board of Finance); Nos 10 and 11 The Close (dated 1727, but the 1680s staircase indicates earlier); and the late-seventeenth-century Judge's Lodging House. Perhaps the one concession to continuity, however, was the survival of the former Prior's House, rightly transformed into the Dean's House.

Reputedly dated 1150, the portico is certainly thirteenth century (although the upper floor is Tudor), the core of the building is fourteenth to fifteenth century, the Great Hall is dated 1459, the Long Gallery dating to 1666–79 (by Dean William Clarke), the central part of the house and staircase seventeenth century, while the South Window is 1805. It was extensively renovated in 1971 and again more recently, in 2016–17. It was where the Prior lived and entertained important guests, the portico being where food would be distributed to pilgrims. An example of the Prior's then lavish style of living (and perhaps one reason for the long-running medieval animosity and friction between Prior, Bishop and the ordinary citizens) was in 1486, when Elizabeth of York, wife of Henry VII, wished to give birth to his son and hoped-for heir, Prince Arthur, in the 'Prior's more luxurious apartments' rather than in the discomfort of the castle.

There is a nice irony that at least part of the ground floor is now given over to a second-hand bookshop; such literature being itself the fruits of the Reformation and Enlightenment.

9. The Great Hall, Winchester Castle

Virtually nothing is now visible above ground of the great eleventh- to fourteenth-century Norman castle, first began by William the Conqueror as early as 1067, and subsequently developed by Henry I (between 1154 and 1189) and Henry III (between 1216 and 1272). The most notable exception (if naturally modified in the centuries since) is the Great Hall, began in 1222 under a master mason named Stephen, and which took fourteen years to construct at the cost of £500; it was completed by Elias of Dereham, who was also responsible for Salisbury Cathedral. Materials were sourced from Selborne (Hampshire), Purbeck in Dorset, Bath, the Isle of Wight and Caen, in Normandy.

It is quite rare in English medieval architecture, in being a perfect double-cube, 111 feet by 55 feet. The original trussed rafter roof was larger and steeper, and the main entrance we see now was remodelled in 1845 by Victorian architect G.E. Street; the former entrances being previously towards the east end. The windows were also altered, notably in the late-eighteenth century. Much earlier, other modifications had been undertaken either in 1348–49 or 1390–1404. However, even now, the interior reflects something of its Early English grandeur. The famous 18-feet-diameter 'King Arthur's' Round Table (which, until 1873, was hung on the east wall) was likely commissioned by Edward I (1272–1307), as dendrochronology sampling of the wood suggested a date between 1250 to 1280. It was probably already on display in the hall by the early sixteenth century, while chronicler John Hardyng mentions it in 1463. It was faithfully repainted in 1789 by Winchester artist William Cave. However, there were certainly alterations made in 1516–17, and X-rays have later showed that the face of Arthur was in the likeness of the young Henry VIII, a clear example of one-upmanship over Holy Roman Emperor Charles V, who visited here in 1522.

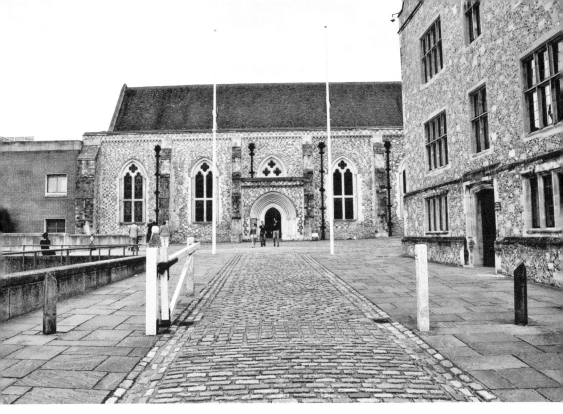

The Great Hall from Castle Avenue.

From at least some of the time of Henry II until 1874, and again from 1938–74, the hall was used as a court of law, and amongst those tried here include Sir Walter Raleigh (1603), Alice Lisle (1685) and sisters Marian and Dolours Price, following an IRA London bombing campaign, in 1973. Architect T. H. Wyatt undertook restoration work in the 1870s, while incorporating the new (but short-lived) Assize Courts, situated to the east. Other new buildings had already appeared to the west of the hall, including the former Grand Jury Chamber (Thomas Whitcombe, 1773–74, refurbished in 1849–52 by O.B. Carter, and again by Wyatt, 1872–73, and now the gift shop and exit), to be followed by barracks buildings and county offices with the construction of Castle Avenue in 1895–96.

Exhibits at the Great Hall include the 1887 bronze statue of Queen Victoria by Sir Arthur Gilbert, which at various times stood in Castle Yard and later Abbey Gardens, before being officially unveiled again here in 1912, and the delightful period-style Queen Eleanor Garden, designed by Dr Sylvia Landsberg, which can be found at the rear.

1c. Westgate

On the site of a Roman, and later Anglo-Saxon, gateway leading towards Romsey and Salisbury, the Westgate we see now was rebuilt in 1240 as part of the overall improvements to strengthen the castle defences undertaken by Henry III. The west elevation was remodelled in the fourteenth century, with innovations such as inverted keyhole gunports. Throughout the medieval period, the gate continued to be an integral part of the castle fortifications with numerous buildings on both sides of the High Street until the

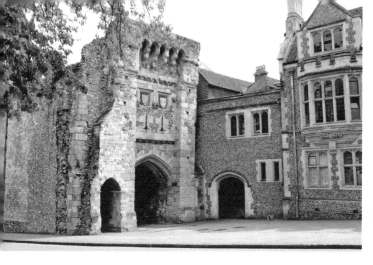

Westgate viewed from Upper High Street (the Victorian buildings are seen on the right).

mid-seventeenth century. By then the castle and some of the city walls had been demolished, leaving the gate freestanding, with only a handful of properties strung out either side, up Castle Hill, and along Tower Street. In much of the upper town buildings had been pulled down, the land often reverting to pasture, and redevelopment of this part of the High Street only began again from the 1830s onward. In 1791 a pedestrian way was cut through on the north side, where once had been the Porter's Lodge.

The Plume of Feathers, an old inn immediately adjoining the gate on the north side, had entrances from both Tower Street and Upper High Street. It was known as The Fighting Cocks until 1790. This was extended and remodelled in 1889 by Alderman and local builder Thomas Stopher (1837–1926), only to be purchased by Hampshire County Council and demolished in 1938, thereby opening up a new road on the north side, although traffic continued to use the old gate also until 1956.

Westgate was a museum and repository for archives in the nineteenth century. It is said it only avoided the fate of Eastgate (demolished in 1768) because the lease had not yet expired and the upstairs was used as a billiard room. In the 1880s there was an upstairs 'smoking room', an integral extension from the adjoining Westgate Hotel and Tavern, which closed as a pub/hotel in 1893. Westgate was Grade I listed in 1950, and again houses a small museum upstairs.

11. St John's House and Hospital

St John's Hospital (named after John the Baptist), in what is now The Broadway, is one of the oldest charitable institutions in the country, being possibly founded by St Brinstan (born c. 870), Bishop of Winchester 931–34. The vaulted kitchen may be part of the original Saxon almshouse, while the original chapel is early thirteenth century. It was re-founded in 1289 with an endowment by John Le Devenish, the hospice being dedicated to 'support old and infirm, needy travellers and the poor of Winchester'. A second chapel was built 1332. In 1400 the Mayor Mark Le Faire left several houses and properties, including the 'house under the penthouse [Pentice] where Mr Hodgson died' and 'the great inn called The George', while in 1428 John Devenish (descendant of the earlier Le Devenish) again endowed the chapel. In 1310, during the reign of Edward II, a chaplain was appointed 'to pray for the souls of English Kings and Queens'. The fourteenth century saw further construction, including a first-floor hall used by the city municipality, the ground floor

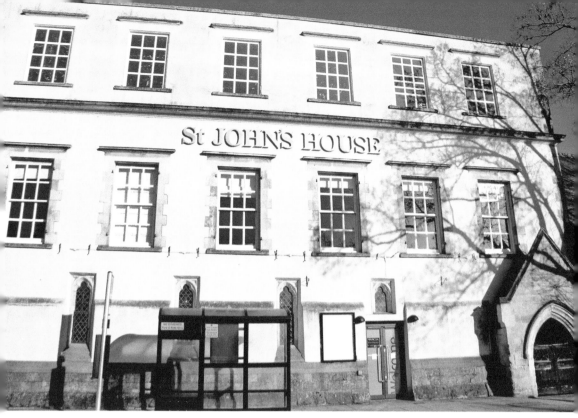

Above: St John's House and Hospital, Broadway. Note the blind upper-storey windows.

Below: St John's House almshouses, Broadway, built in the 1830s.

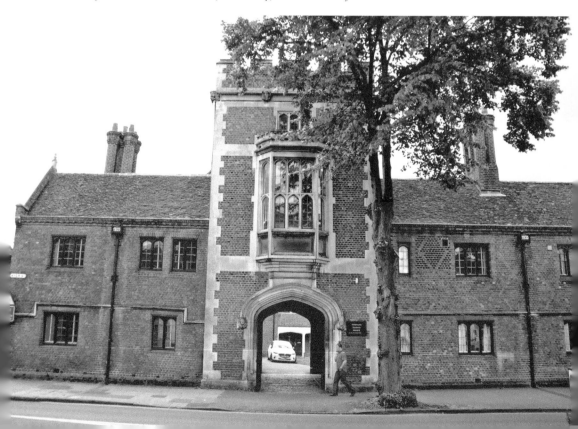

being the hospital hall. During the Dissolution, while some funds *were* appropriated, it escaped suppression by virtue of being described as a hospital, and a fresh endowment in 1558 by Ralph Lamb of £400 enabled the first five almshouses to be built. By then the building had come under the control of the Mayor and City Corporation (this being confirmed by a royal charter dated 1581), and it was thereafter used for municipal elections and assembly, and – following more alterations in the eighteenth century, when the roof was raised another 7 feet (note the fake upper floor windows) – for banquets and concerts, as well as law courts. Prisoners' cells were in the undercroft, which is today a café.

The chapel, having been desecrated during the Reformation, was later converted into a school for 'sixty poor children' from 1710–1838. In 1811 residents and wardens of the local parishes petitioned in Chancery against maladministration by the City Corporation using charitable legacies for wider purposes, and in 1829 this was eventually found in their favour, after which a charity scheme was established which, with a few variations, is still that of the organisation today. The south side almshouses were built in 1817, and 1831–34 by architect William Garbett (completed by Owen Browne Carter), the façade facing Eastgate Street looking little different. The twenty-two north side almshouses, to the east of Busket Lane (Saxon *Bucchestret*), date from 1856 ('1862' on the rain water heads). Both were Grade II listed in 1950, while St John's House is Grade I listed. Later amalgamations with St Mary Magdalen in Colebrook Street and Peter Symonds' Christes Hospital mean the four sites have seventy-nine units, housing between ninety and 100 residents. More recent additions include Devenish House in Southgate Street (a nursing home built in 1990, with twenty beds), and Moorside, North Walls (a nursing home built in 1996, with twenty-six beds). The name was changed to St John Winchester Charity in 1984, and income continues to be generated by property investment.

12. Cheyney Court, Old Stables and Pilgrims' Hall

In Winchester it's often difficult to isolate specific buildings which over the centuries have become integrated, architecturally and historically. Cheyney Court, reputedly 'the most photographed building in Winchester', is one example; just part of a cluster of interlinked buildings fringing the south of Cathedral Close. Dating from the mid-fifteenth century and partly built into the medieval wall (the rear can be seen from College Street), it was formerly the seat of the Bishop's judicial power over the city, serving as courthouse of the Soke (outside the east and south gates) from medieval times until 1835 (favoured in particular for the recovery of debts). Sessions were formerly held every Thursday, except on certain saints' days. Plaster having been removed from the exterior in 1888, it is now perhaps the archetype image of a Tudor house, and illustrations and photographs show it to have been little changed from that time on. Peter Kilby described it thus: 'The elevation overall has a somewhat higgledy-piggledy arrangement of windows with one squeezed in to form a fourth level in the Porter's Lodge, but the informality adds to its charm.' The tiny room built out over the late-fifteenth-century Priory Gate was once part of the cathedral organist's house. The massive iron-studded oak gates, leading out to Kingsgate, are still closed at ten o'clock every night. Immediately opposite Priory Gate, extending at right angles from Cheyney Court, are the Old Stables, dating from 1479 to the early sixteenth century (thereby predating the dissolution of the Priority); two-storeys and attic, timber-framed with brick infill at ground level, plaster above, with a tiled roof and gabled dormers.

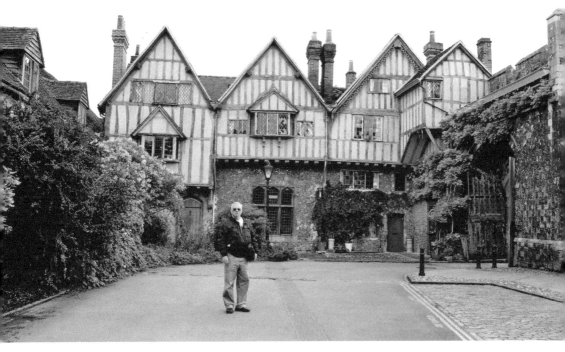

Above: Cheyney Court, Cathedral Close Gateway and Old Stables (and one of the authors) in 2011.

Below: The Pilgrims' Hall, Cathedral Close.

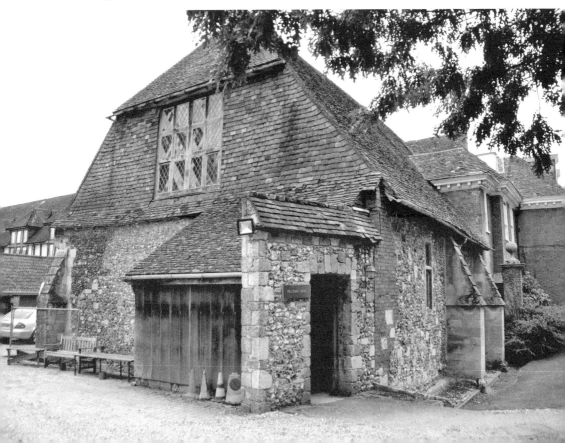

Set back across the green of Mirabel Close is the Pilgrims' School, an independent preparatory and boarding school with roots stretching back to the Saxon era (seventh century), initially for educating the Minster choirboys. The school moved here in 1931, and its alumni include comedian Jack Dee, television journalist Jon Snow, and sculptor Anthony Smith. Built on the site of a former Roman villa, the main building dates from the 1680s (although with later alterations) and is attributed to Sir Christopher Wren. Attached on the north side, however, is what has been known since Victorian times as the Pilgrims' Hall; a medieval barn-like hall with stone-flagged floor, plastered walls, and a rough hewn oak hammer-beam roof formerly believed to date to the early fourteenth century, but dendrochronology dating of the roof timbers suggests it was built in the 1290s, making it the oldest surviving such structure in England. Tradition has it that medieval pilgrims to St Swithun's shrine were welcome to spend the night here, and allowed to dine on the leftovers from the Prior's lavish banquets. All of the above have been Grade I listed since 1950.

13. The Old Blue Boar Inn

Today St John's Street is a side road, but once it was the Roman, and later a drover's, road leading out east across Magdelen Hill towards the downs. St John's Church, which had a close scholastic connection to Winchester College in medieval times, was built on or near a Romano-British cemetery and is often dated to *c.* 1142, but is probably much older, although the tower is fifteenth century. At what is now No. 25 is the former Old Blue Boar Inn, although it had already reverted to being residential by the nineteenth century. It stands at the junction of St John's Street, the oddly named Beggars Lane, and Blue Ball Hill, seeming a corruption of Blue Boar, but which as long ago as the 1871 OS map was then

The Old Blue Boar Inn, St John's Street, Soke.

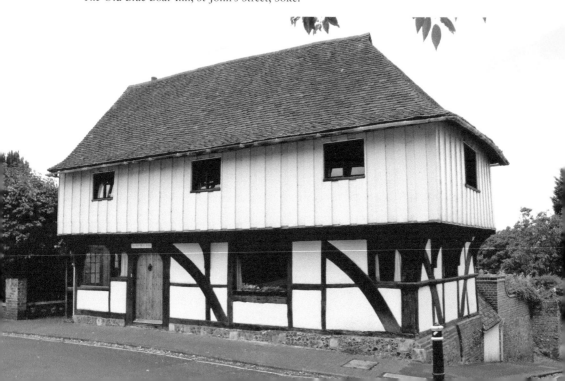

named Redhouse Lane. It was only renamed sometime between the late 1940s and 1951. Reputed to be the 'oldest house in Winchester', it dates from around 1340, and probably functioned as both a shop and a pub. Phil Yates (2007) says it was originally named The White Boar, that being the personal emblem of Richard III. After he was killed at the Battle of Bosworth in 1485, and the Tudor Henry VII emerged victorious, it was said that many publicans hurriedly changed the name of their establishments to The Blue Boar, badge of the 13th Earl of Oxford, a key Lancastrian supporter. It was subsequent 'ignorance' by the city council that the inn name and nearby road got misnamed as 'Blue Ball'.

As an inn, its moment of apparent notoriety was in 1764 when twenty-six-year-old Grenadier Thomas Fletcher purchased and consumed a mild beer, only to die afterwards of a fever. He was buried in the cloister of Winchester College with the warning on his tombstone: 'Soldiers be wise from his untimely fall, And when you're hot, drink Strong or none at all.' It was used as a cottage from the late-eighteenth century; the garden being on the edge of a Roman burial ground. By the twentieth century the property had fallen into disrepair, empty from 1962 and suffering further damage in 1966, when it was accidentally hit by the jib of a crane. Purchased for £28,000, Winchester architect Wilfred Carpenter Turner (at one time cathedral architect), together with HJA Developments, carried out a careful restoration between 1969 and 1970. It is believed to be the only example of a timber-frame double-galleried hall-house in the country. It was again refurbished in 1985.

In 1076, Waltheof, the Saxon 1st Earl of Northumbria, was executed on St Giles' Hill by orders of William I, and his body reputedly buried at the crossroads, only to be later dug up and reburied in Crowland Abbey, Lincolnshire. St Hubert's Cross once stood opposite (referred to as Hubb's Cross in Tudor times and Bub's Cross in 1750), and the site was still marked as such on nineteenth-century OS maps.

14. The Pentice, Nos 30–41 High Street

The medieval word *pentice* or pent-house signified a shed hanging at a slope from the main wall, and was applied to this part of the High Street from the thirteenth century onward (although it was also known as the *Piazza* in Victorian times). It is a rare surviving example of what may have once been commonplace in medieval towns or cities; one explanation suggesting the then tax levied on houses or shops taking space on the 'King's Highway', so people took to constructing cellars and extended the upper storey out over the street below. Although the Minster boundary ran in line with the north wall of St Lawrence, much of this location south of the High Street was – from the Saxon age through to the Plantagenet period – the site of the Regal Palace and Royal Mint. The latter, which probably give rise to the tavern name 'Helle' (where No. 41 is now), was burnt down in 1180, but soon rebuilt, only finally ceasing operations in 1279, when England's various mints were centralised at the Tower of London. From the thirteenth to early fourteenth century this 249-feet-long stretch of High Street (now Nos 30–41) was dominated by the drapery trade, being known as the *Draperia*, or Drapery Row, but, contrary to the oft-quoted *c.* 1250 date, the oldest existing structure we see now is from the fourteenth or fifteenth century.

What we see today is actually a mishmash of styles, rebuilds and alterations over half a millennium, although the surviving gabled fronts of Nos 31, 33–35 are probably how the roofline might have once appeared. No. 32, now Jeremy French Jewellers, is a rather

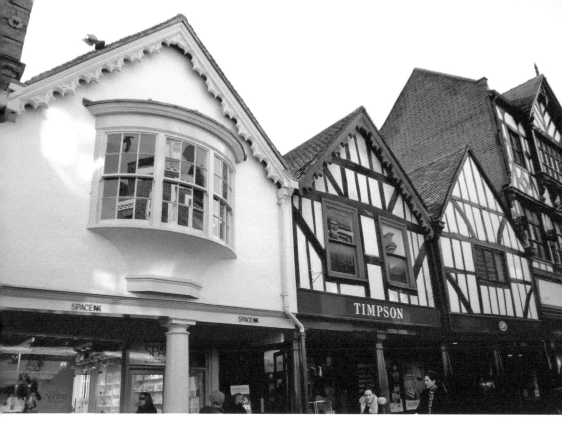

Above: The Pentice: Nos 33–36 High Street, still featuring the old medieval roofline.

Below: The Pentice: the medieval timbers and roof inside No. 33.

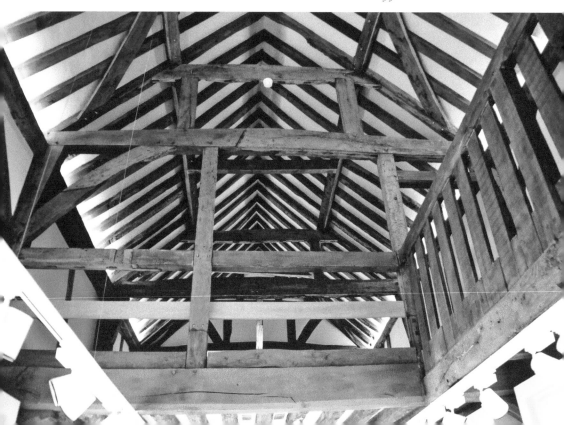

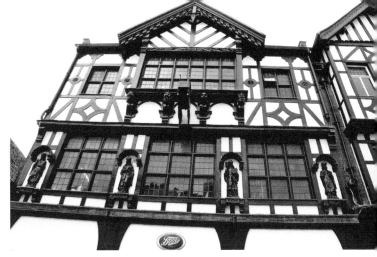

The Pentice, Nos 33–38 High Street. Boots the Chemist's façade dates from the early twentieth century.

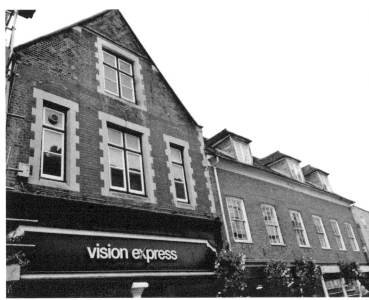

The Pentice, Nos 39–41 High Street.

insensitive Victorian rebuild from around 1871, but Nos 33–34 have been dated by dendrochronology to 1459–62, the former (now Spacenk Apothecary) still has the upper gallery and timber roof, the shop ceiling-beams actually extending from the Pentice walk. No. 34, now Timpson, was formerly the old Edinburgh Castle public house, then from 1871 until the 1970s Thomas Foster (tobacconists); while set back behind No. 35 (now part of Boots the Chemist, but until the 1960s Baker the ironmongers) is a rare example of the remains of a hall of a Wealden house, once much larger, dating from 1340, while the front forebuilding is fifteenth century. Boots (Nos 35–39) has dominated this part of the High Street since purchasing the core shops (Nos 37–38) from the auctioneers/estate agents Gudgeon & Sons in 1903 for £4,150. Now three storeys (although the upper floors are currently unused), the 1905 impressive black-and-white mock-Tudor façade is by Michael Vyne Treleaven (1850–1934), the self-taught company in-house architect from the 1890s until around 1913. Winchester was just one of many buildings by him in this style, up and down the country. From the 1890s, No. 39 was the International Tea Company, before becoming Burton Montague Tailors between the 1930s and 1960s. No.

40 is another nineteenth-century street frontage, having been a butcher's for the first half of the last century, then a shoe shop, and today Vision Express opticians. Number 41a was formerly Bishop Bros, boot-makers, then Benetton in the 1970s and today Reeve the Baker. Cellar steps can still be seen in No. 35, while those beneath Nos 41a and 41 are fourteenth century. Cellars beneath Boots stretch back as far as the Square, and are still used, although are reportedly rather spooky!

15. Winchester College Chapel

William of Wykeham founded both New College Oxford (1379) and Winchester College (1382) using the same blueprint, with the chapel and Chamber Court at its heart. Stonemason William Wynford began construction of the impressive, almost cathedral-size chapel in 1385, using Quarr Stone from the Isle of Wight. In 2000 an authentic medieval-style limewash was applied to the stone on the north side, something once widely seen at that period. The entrance passageway to the chapel was reworked by William Butterfield in the 1860s, commemorating old Wykehamists who fought in the 1853–56 Crimean War.

The lofty ceiling was carved by Hugh Herland, with dramatic red edging and elegant fluted vaulting; while each boss was carved with foliate decoration and grotesque faces. This exquisite carving continues with the original fourteenth-century choir pews. The central pews are early twentieth-century replacements, now facing east to increase

The north side of Winchester College Chapel with medieval-style limewash.

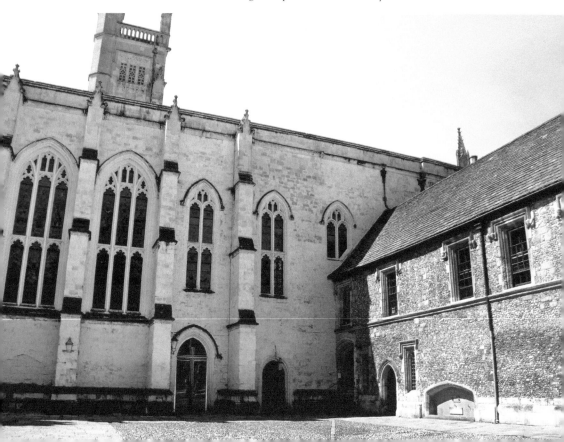

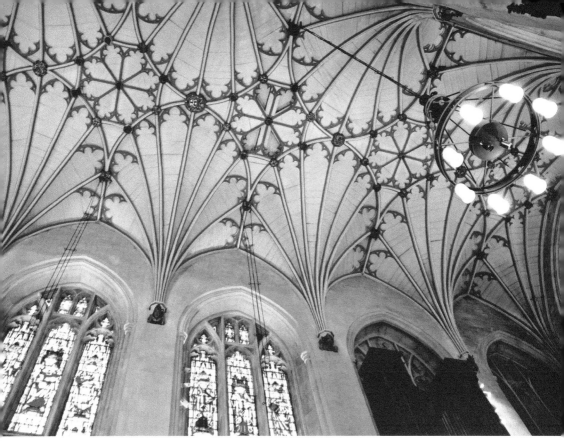

The original ceiling inside Winchester College Chapel.

seating capacity. As William intended the pre-Reformation college to be almost monastic in practice, scholars were required to attend between two and three services a day, the teaching priests between five and six. Then and now, music continues to be important, with two large organs dominating both north and west sides, creating a range of sounds. Sixteen young treble 'Quiristers', voices unbroken, are still enrolled to sing choral services.

The last medieval part of the chapel to be completed was the east window, glazed by Thomas of Oxford, styled as a family tree. It begins with the portrait of Jesse, father of Biblical King David, but (most unusually) also includes figures of the four master craftsmen: Simon of Membury, Herland, Wynford and Thomas of Oxford. The tree culminates with the Virgin Mary and baby Jesus, then the Crucifixion and Last Judgement. Founder William of Wykeham has been depicted twice, once as a witness to the Annunciation. Remarkably, the window survived the Reformation and English Civil War, but in 1821 the glass was badly discoloured and deemed irreparable, so a replica was commissioned, made by Shrewsbury glassmakers Betton & Evans; the original panes sold or lost. A century later, in honour of Headmaster Dr Rendall (1911–1924), the school – with support of art historian and old Wykehamist Kenneth Clark (1903–1983) – began to recover the original glass. Dennis King was able to restore some (1949–51), including one piece loaned by the Victoria & Albert Museum, into the Thurbern Chantry. This fifteenth-century extension (commemorating College Warden Robert Thurbern, 1413–50) is located under the bell tower, and owing to subsidence had to be dismantled and rebuilt brick by brick by William Butterfield in the nineteenth century.

16. The Royal Oak Public House

The Royal Oak, situated in the alleyway of God Begot House, claims to be England's oldest pub or brewhouse, but it certainly has royal connections to around 1002, being part of the *Godebiete* site. It was traditional for Saxon monarchs and their spouses to live in different residences, the houses or shops thereon also providing Queen Emma with additional income. It was likely at this manor that she raised their son, later Edward the Confessor. The still medieval-looking alleyway upon which the Royal Oak is situated was not only the boundary to the Jewish ghetto (until the thirteenth century), but also part of the High Street's hollow-way, a sunken track almost sculptured into the land by centuries of repetitive use. Recent excavations indicate this may even have predated the Roman period. The pub itself covers three levels: the cellar, the bar and the extension, all being built into and over the hollow-way. Although the building we see today dates from the 1630s, flint remains in the cellar suggest a date in the twelfth century, while the base of the corner-stones could even be pre-Norman Conquest. The Winton Domesday Book (*c.* 1110) shows that a door and two windows were blocked up, suggesting the original use of the cellar to be a type of shop known as a *seld*. The first reference of the building as a pub or inn was 1390–1430, when an un-named 'taverner' was recorded living there. In 1637 records show that a John Chase and his wife living on the premises also stored a 'brew house'.

The Royal Oak public house viewed from St George's Street.

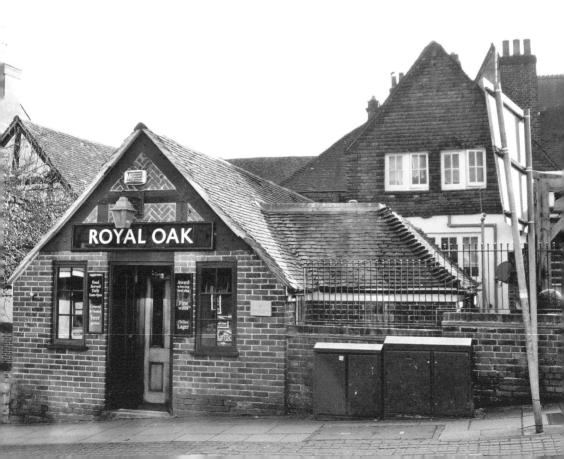

It was only after the English Civil War that the pub gained the name of Royal Oak. Winchester was a royal stronghold, and after the execution of Charles I and the fleeing of his son (later Charles II), supporters of the Crown would secretly wear an oak leaf (Charles the son having hidden in an oak tree to avoid capture), to show their loyalty. Therefore, after the Glorious Restoration in 1660 and Charles residing in Winchester, the pub became 'commonly known as the Royal Oak'. In the property deeds of 1677, the Royal Oak was described as having a brew-house, a parlour, three drinking rooms, a bar, a cellar, a kitchen and a garden, which housed benches, apricot trees, two vines and a hen coop. By the mid-eighteenth century brick cladding had been added to the outside. However, while the old beams and slopped structure are authentic, together with the cellar, much of the interior we see today is comparatively modern.

17. Fromond's Chantry and Winchester College Cloisters

Winchester College has two cloister garths. The oldest (1395) uniquely has a two-storey John Fromond Chantry constructed in the middle. This was built in 1425–46 by Warden Thurbern, with money bequeathed by Fromond, steward of the College estates. He and his wife Maud (d. 1420 and 1422 respectively) were buried in the cloister and the building erected over their graves. Their stone figures are carved above the entrance. The ground floor was intended as the chapel where Masses were chanted for the rapid progress of souls through Purgatory into Heaven – a forbidden practice following the Reformation. A library

The medieval cloister of Winchester College, with the chapel on the right.

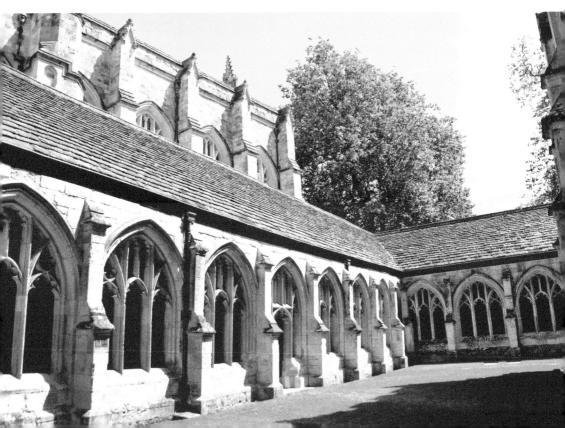

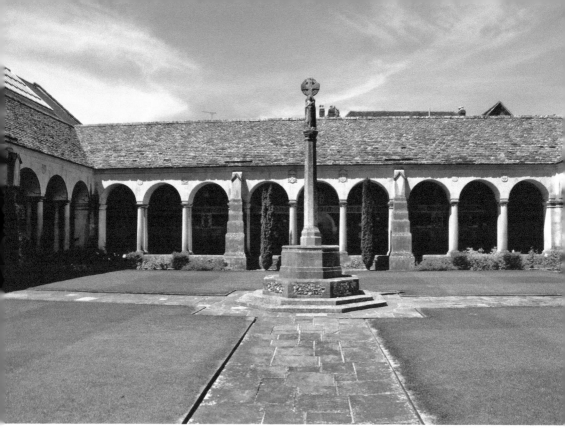

The War Memorial in the cloister of Winchester College.

was originally above, later used as a grain store but which now houses part of the college archives. Original fourteenth-century glass has survived and reset in the east window, while the west window (1950) is in grisaille style, depicting delicate lilies – the emblem of the Virgin Mary. Also notable within the serenity of the barrel-vaulted cloisters is a plaque to old Wykehamist George Mallory (1886–1924), who died climbing Mount Everest.

The War Cloister (1922–24) is the largest privately owned war memorial in Europe, the conception of Headmaster Montague Rendall following the loss of virtually an entire generation of pupils in the First World War, with 500 names inscribed on the outer walls (the College intake at that time was 450). The names of those who fell during the Second World War are carved onto the inner columns. It was designed by eminent architect Sir Herbert Baker (1862–1946) and dedicated by the Duke of Connaught on 31 May 1924. The high-roofed quadrangle has 120 regimental badges represented on the rafter beams, while the then four quarters of the Empire (Africa, Australasia, India, Canada/the West Indies) are so honoured in each corner, with Reginald Gleadowe's unique Lombardic script running throughout. This may have been the first time the Indian provinces' emblems were thus displayed, having only recently being granted. The original planting scheme was by Gertrude Jekyll, but a new scheme was created in 2014. It is complimented by the medieval-style flint exterior and tall metal gates supported by trumpeting angels, while in the centre of the cloister is an octagonal foundation stone and remembrance cross, flanked by two crusader knights. Originally Grade II listed in 1950, it was elevated to Grade I in 2017. In addition to its function of commemoration, reflection and sanctuary, the cloister is still used today as a thoroughfare to and from the boarding houses.

18. Chesil Rectory

With the date of 1459 above the door, this building is reputedly the oldest commercial property in Winchester, built by a wealthy merchant. While some sources think it even earlier (1420s), a City of Winchester survey believes the building to be more probably sixteenth century. No. 1 Chesil Street was once popularly known as Cheese House, this being formerly called Cheesehill Street – still appearing thus on the 1897 OS map. However, the name is apparently derived from the Anglo-Saxon *ceosel*, meaning 'gravel', perhaps referring to the River Itchen's beach where ships once landed. The building is quite unusual, perhaps unique, in that the entire weight of the central valley of the double roof does not fall onto the supporting walls, but rather via four vertical beams, and rests on the central beam of the downstairs passageway. The original doorway was used as an entrance for livestock, then leading through onto a stone pathway running from front-to-back. Fireplaces were only added in the sixteenth century, so originally the house would have had simple vents in the roof; the interior walls and roof would have been blackened with soot. The front of the building, with its upper parts over-sailing the brick ground floor, is almost all original, with only the windows later being altered from simple wooden shutters or bars to glass.

After the Reformation, the building became a refectory house for St Peter Cheesehill, and around 1760 the house was split in two; the division was only removed in 1890. One of these tenants was a shoemaker, who reputedly opened the large upstairs room to become Winchester's first 'Sabbath School', although there is nothing to substantiate that claim. With the construction of the Didcot, Newbury & Southampton Railway in 1885, the buildings immediately next to the Rectory were demolished to create the station approach, followed, around 1905, by the adjacent buildings on the Bridge Street side for road widening. By then looking shabby and semi-derelict, the Rectory too was under threat. Fortunately it was saved by the intervention of Thomas and Co. Stores, who bought

The Old Rectory (now a restaurant) in Chesil Street.

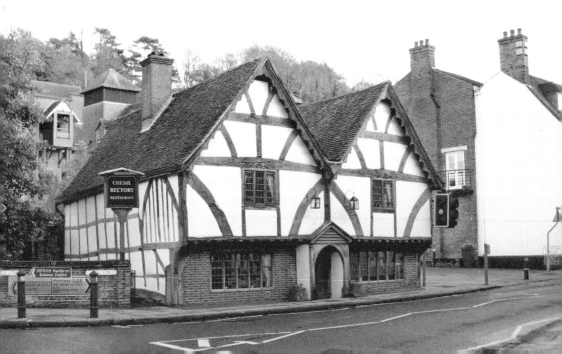

the building and started renovation in 1892–93. Now standing in isolation, it underwent further restoration, being re-roofed in 1960. It has now been a restaurant for nearly seventy-five years, and has formally been a tearoom and antiques' shop.

19. God Begot House

Like the Royal Oak, what is now God Begot House had a very regal beginning, being gifted to Queen Emma, wife of Ethelred II (the Unready) in 1012 as part of the God Begot estate north of the High Street. She in turn then donated it to the Priory of St Swithun. The core building (1462) was a holy residence, wherein medieval lawbreakers could seek sanctuary. It was severely affected by the Reformation and was rebuilt in 1558. However, the mock-Tudor exterior façade we see now was the creation of bookseller/stationer Mr James Pamplin (*c.* 1821–1887) and his daughter, Ellen Louisa Pamplin (1855–1937), who occupied the property between 1865 and 1927. After her father's death, Ellen (the eldest of his children, who remained a spinster) later converted the house from a shop into a 'high-class private hotel', adding the new fashionable Tudor look in 1908, styling it 'Ye Olde Hostel of God Begot'. This was apparently paid for by J. P. (Pierpont) Morgan (1837–1913), the American banker and financer, whom Miss Pamplin apparently knew.

Ellen may have created an elitist inn, but she also recognised the religious foundations of the house, becoming a generous benefactor to the cathedral and using the hotel to hold annual

God Begot House in the High Street (now ASK restaurant).

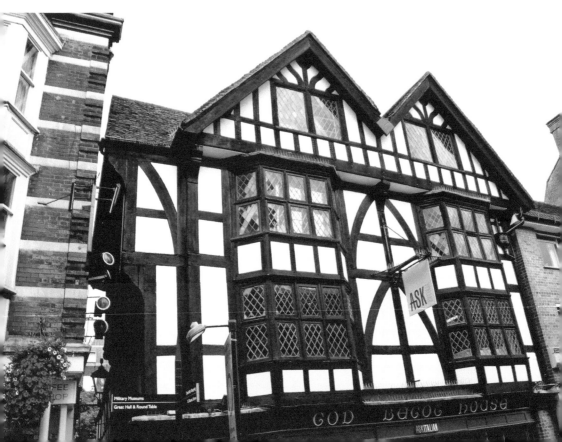

Christmas parties for the Quiristers and girls from Winchester High School during the First World War. Unfortunately, following her death, modern fire regulations curtailed it continuing as a hotel, and it reverted back to a shop and, later, a restaurant. At the time of writing it is currently an ASK Italian restaurant. It was Grade II listed in 1950 and restored in 1958.

2C. Nos 41–43 High Street and the City Cross

After the cathedral, and the more recent Victorian grandeur of the Guildhall, the 'heart' of Winchester is the Buttercross (or City Cross), located at the Saxon entrance to the former Royal Palace and cathedral Minster. The more popular name reflects the time when dairy produce, including milk and cheese, would have been sold here. It is dated to perhaps 1422, possibly a gift from Henry Beaufort (*c.* 1375–1447, Bishop of Winchester from 1404), but it may have replaced a still older Saxon cross. Originally it would have been replete with figures, including the saints of many of the major city churches, plus William of Wykeham, King Alfred and either St John the Evangelist or St Amphibalus (d. 304, a contemporary of St Alban the martyr). Having survived the Reformation and Civil War, in 1770 it was sold by the newly formed Paving Commissioners to wealthy landowner Thomas Dummer (1739–1781) who wished to remove it to his estate at Cranbury Park, near Otterbourne. However, when his workmen attempted to dismantle it, the citizens 'organised a small riot' and eventually the sale was rescinded, Dummer being forced to erect a lath and plaster

Nos 42–43 High Street and the Buttercross.

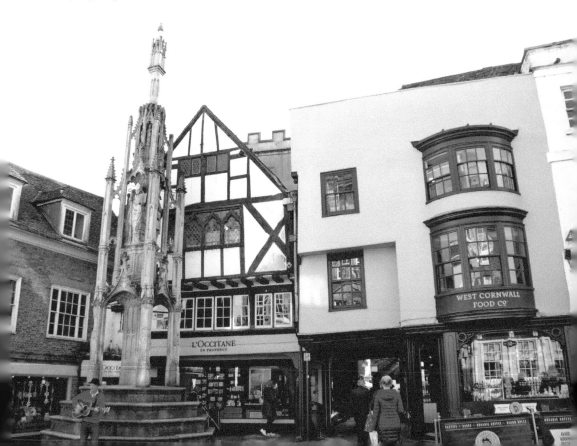

facsimile, which eventually fell apart around sixty years later. Renovated around 1800, it was later 'radically restored' by Victorian architect George Gilbert Scott (1811–1878) in 1865, completely rebuilding the upper part. Only the statue of St John is original.

The buildings either side of the old Saxon gateway (Nos 42–43) have outwardly little changed over the last 200 years, forming a harmonious whole. Indeed, on the detailed 1875 OS map, Nos 41–41a and 42 are internally as one, and at No. 41 there is still a blocked-up doorway in the far wall. From 1880 No. 41 housed Alfred Tanner, stationer, but by the late 1890s it was City Cross Refreshments, although listed to William George Allen and Charles O'Neill, continuing as Allen's Confectioners into the 1960s. By the 1970s it was Anglia Building Society (defunct 1987), also listed in Warren's Directory of 1972/3 as Winchester Travel Agents. It is now Montezuma's Chocolates. No. 42 is listed (all were grade II listed in 1950) as 'C15–16, much altered, four-storey, timber-framed, plastered gable, two upper floors over-sailing on brackets...tile roof...[contains] remains of Norman Palace.' In the 1951 Warren's Directory it was Tyrrell & Green, drapers (the bigger Southampton store was in Above Bar Street, Southampton, now John Lewis in Westquay), and in the 1960s until the early 1970s it was Lowman's bakers/pastry cooks. More recently it was Pasty Presto, with public access to the upper floor, but is currently L'Occitane en Provence Perfumes. The 1930 Warren's Directory listed No. 43a as The Norman Palace Tea Rooms. No. 43 is now West Cornwall Food Co., with access to the upper floor.

There exists an 1848 lithograph (now in the Royal Collection) by architect Owen Browne Carter, which proposed completely demolishing Nos 42–44 for a new road sweeping past the Buttercross and a rebuilt St Lawrence, to a formal cathedral gateway (not unlike that of the College) where the City Museum is now. Fortunately, it never got built.

21. The Former Church of St Maurice

Like nearby St Lawrence, the former church of St Maurice may have a Saxon pedigree, being perhaps originally a gate chapel from the High Street into the New Minster. As such, even now it is still a public right of way. The first recorded rector is dated 1560, but the archway to the tower (all that now remains of the church) is eleventh- or twelfth-century Norman. It became a joint parish with St Mary Kalender (once located opposite The Pentice) and St Peter Colebrook in 1682–83. Following a major fire, the old church was demolished in 1840 and rebuilt by William Gover in 1842 in a typical early Victorian style at the cost of £3,670, whilst 'retaining some Romanesque features' (Beaumont James, 1997), but still fronting directly onto the High Street. Another £520 was spent on further restoration in 1872. *The History of the County of Hampshire* (1912) describes it being 'shut in between a draper's shop on its east and butcher's shop on its west. A dark passage, St Maurice's Passage, between butcher's shop and church, leads past a slaughterhouse to Spicer's Corner, and thence to the Cathedral cemetery.' Although the tower ('heavily repaired' in 1842) was Grade II listed in 1950, the rest of the church was demolished in 1957–58, and the tower gateway – the south side now known as St Maurice Covert – has been rather incongruously incorporated into the modern structure of what is now Debenhams department store, where it serves as a fire escape to the top-floor Cathedral View Restaurant. From at least the 1890s this was formerly Sherriff & Ward (originally Nos 12–15 High Street), later one of many such local department stores taken over by the Debenhams Group. The existing

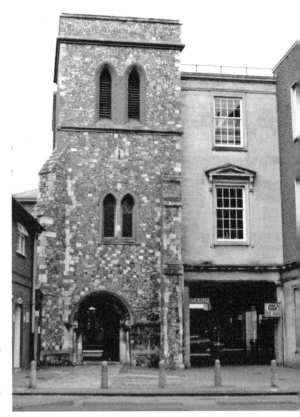

Right: St Maurice's Tower from Market Street, *c*. 1988.

Below: (St Maurice's Tower wall inside Debenham's restaurant.

store was constructed and enlarged in 1960, but was still under the Sherriff & Ward name until 1977. The church's original pipe organ, dated *c.* 1690 and installed in 1756, was later removed to St Thomas in Southgate Street, and when (in 1969) that also closed as a church, it moved again to St Denys Church, Portswood.

St Maurice (also Moritz or Morris) was reputed to have been a soldier-saint born around 250–287, serving with the Roman 'Theban Legion' in what is now modern-day Switzerland, although many historians question the truth of the legends attributed to him. He became the patron saint of the Holy Roman Empire in 926, and is perhaps better known in mainland Europe, as well as being revered by the Christian Coptic Church in his native Egypt.

22. Christ's Hospital Almshouses

Peter Symonds (*c.* 1528–86/7) was the scion of a wealthy and influential Winchester family. His father John was bailiff (1565–67 and 1580), while his brother William was three times Mayor (1575, 1585 and 1596). Peter himself was also a merchant and member of the London Mercer's Company, owning land and property in Chadwell, West Ham (then in Essex) and East Shalford (Surrey). By the early 1580s he was one of the richest men in London, most of his wealth derived from the cloth trade. Following his death, sometime between April 1586 and July 1587, his land and property went first to his wife Anne, who he married 1576, but upon her demise, he posthumously directed trustees (including his brother William and the then warden of New College) to secure a licence and Act of Parliament for an almshouse in Winchester named Christes Hospital, together with annual

Christ's Hospital and almshouses in Symonds Street.

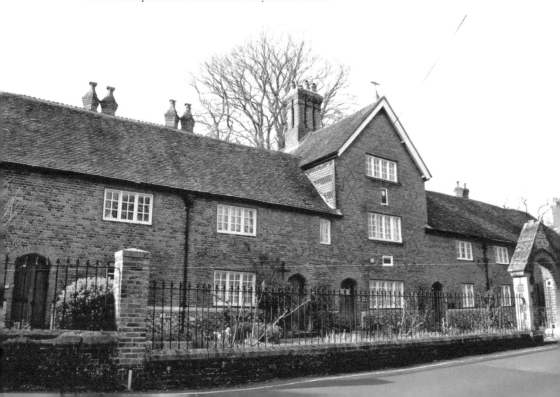

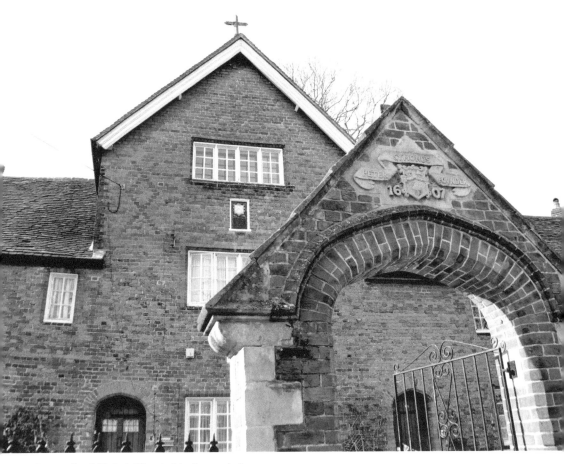

Gate arch of Christ's Hospital in Symonds Street.

payments for charitable purposes. However, there followed a legal dispute over property and it was not until 1600 that the City Corporation were able to secure the land west of the Cathedral Close, between St Swithun's Street and Little Minister Street, then known only as Minister Street. From at least the early fourteenth century this area had comprised cottages and gardens (alternatively known as *Fauconerescornere* or *Mottescornere*), but was a 'single garden held by William Simonds' when acquired by the city in 1590. Construction began in 1604 and was not completed until 1607, with royal consent granted in 1615 by James I. Nos 1–6 were later altered, while the grey brick No. 7 dates from the mid-nineteenth century. The terms of the endowment can still be seen on a plaque on the main building, which reads: 'The Endowments of this House are applied to the maintenance of Six Old Men, One Matron, and Four Boys, and also to the assistance of one Scholar in each of the Two English Universities. The name of such a Benefactor is remembered with gratitude by Posterity.'

It was amalgamated with St John's Hospital charity in 1991, but still continues to provide quarters for poor bachelors and widowers of good character over the age of 50, although now wives are allowed and may stay if later widowed. Another request still honoured is an annual remembrance Evensong at the cathedral on St Peter's Day, 29 June. By the 1890s money from the sale of land was used to establish the Peter Symonds School (now a sixth form college) in 1897, originally in Southgate Street, now Owens Road, and which currently has over 4,000 students aged 16–18.

23. The Old Guildhall

Although often referred to as the Old Guildhall this is something of a misnomer, as it was not the meeting place of the City Corporation but (from around 1349) the site of the Hall of Court where the City Mayor and two bailiffs heard cases in the Court of Records. Although the original medieval buildings were altered in the sixteenth and seventeenth century, by 1693 it was 'ruinous and out of repair' and finally rebuilt in 1712–13, having 'fine noble stone columns, of the Tuscan order...with a tower containing the curfew bell.' The statue of Queen Anne (1665–1714, monarch from 1702) was presented by George Bridges MP, with the commemorative tablet inscribed *Anno Pacifico, Anna Regina 1713*, and the clock installed a year later by political rival Lord William Paulett MP. The original bracket and dial was later replaced by local clockmaker Edwin Laverty when King & Son (the drapers who had occupied the building in the early part of the twentieth century) went into liquidation. The clock (which was repaired in 2010) was reputed to be the first in southern England to be illuminated by gaslight. In a tradition stretching back to the eleventh century, the curfew bell is still rung from the corner turret every evening at 8 p.m.

Between 1835 and 1873 the upper-floor chambers served as a meeting place for the Corporation. However, a line drawing dated 1909 shows the lower-half of the street façade (then still a drapers) with a row of at least eight square windows above the ground-floor shop windows. This façade was remodelled by Thomas Stopher the Younger in 1915 when Lloyds Bank took it over, and the mezzanine floor was removed. In 1918 Lloyds absorbed Capital & Counties Bank at No. 82 High Street (now Connells Estate Agents).

The Old Guildhall, No. 49 High Street (now Lloyds Bank).

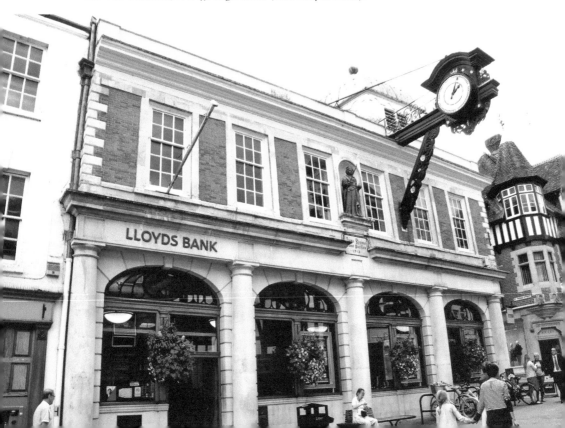

The curfew belfry.

They were merged into the Old Guildhall branch in 1923. In 1957 Lloyds acquired the adjoining building, No. 48, once part of the White Hart Hotel (rebuilt in 1806 by George Moneypenny; it ceased trading in 1857), and interior alterations were made by Peter Sawyer, increasing customer space. Cashpoint machines were installed in 1974, and through-the-wall ATM machines in 1980, while another refurbishment was undertaken in 1996.

24. Serle's House – The Royal Hampshire Regiment Museum

The original site of an old cherry orchard, bowling ground and dwelling house was bought for £300 as one of the parcels of land acquired in the 1680s as part of Sir Christopher Wren's grand design to adjoin the King's Palace to the cathedral. However, following Wren's death in 1723, this was abandoned and the site was purchased by William Sheldon (d. 1749), whose father had been an equerry to King James II. Given that it was rare to find such a large plot of land so close to the city centre, he soon commissioned Thomas Archer to build a large house in around 1730.

However, it was after 1781, when lawyer James Serle bought the house, that his son Peter established the long-lasting link to the military. Having joined – and soon in command of – a Corps of Hampshire Volunteers, in 1804 he became commanding officer of the South Hampshire Militia, eventually rising to the rank of Colonel. During this time, even whilst the family were still in residence, the house became, in effect, a regimental headquarters, and it later became incorporated into the Lower Barracks, Peter having sold the property

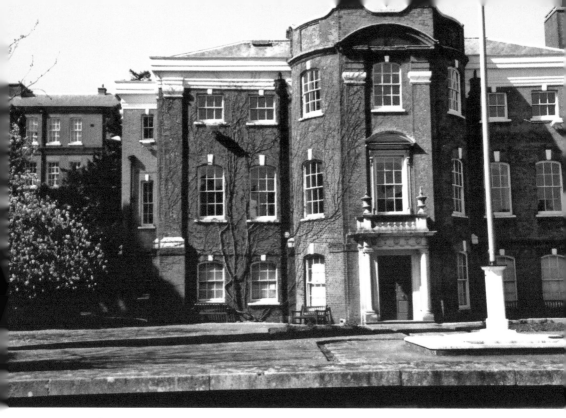

Above: Serle's House: the Royal Hampshire Regimental Museum, *c*. 2014.

Below: The original front of Serle's House, viewed from Gar Street side, 2017.

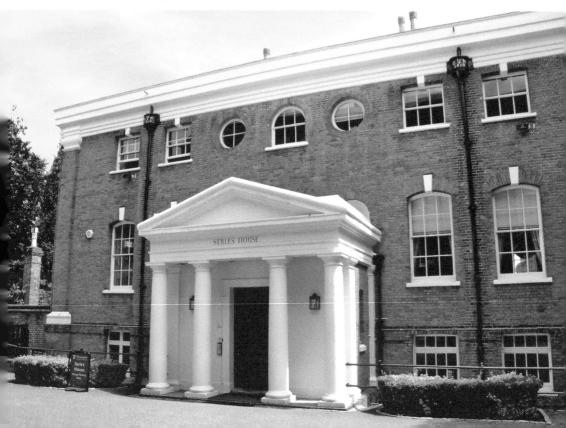

in 1796 to the government for £3,750. He died in 1826, but the property continued to serve both military and civil function, as Militia Headquarters, married quarters for officers of the garrison, Officers' Mess, and even as the Judges' Lodgings for the Assizes in around 1859.

The Lower Barracks was effectively decommissioned from 1959, with many buildings converted to private residential use in the late 1990s, but the Ministry of Defence retained Serle's House as the Royal Hampshire Regiment Museum. The memorial garden was officially opened by the then Lord Lieutenant of Hampshire, Gerald Wellesley (1885–1972, 7th Duke of Wellington from 1943), and dedicated by the Lord Bishop of Winchester in May 1952. What is now the museum entrance, facing Southgate Street, was once the rear of the property, the front originally facing onto Bowling Green Lane (formerly Saxon Gar Street), which was effectively eradicated to make way for the barracks. The house was Grade II listed in 1974. In 2002, the museum's wrought-iron gates and red brick walls were designed in appropriate eighteenth-century style by Colonel P. R. Sawyer. In 1992, after 290 years of existence, the Royal Hampshire Regiment was amalgamated with The Queen's Regiment to form The Princess of Wales's Royal Regiment.

25. Winchester City Mill

This watermill is on the site of what was one of, if not *the* oldest working mill in the country, perhaps dating back to AD 932, when it was granted to the Benedictine nunnery of Wherwell Abbey by Queen Elfrida, and then named the East Gate Mill after its location. However, the defensive medieval gateway was dismantled in 1768–74 to allow free movement of traffic, and the current road bridge we see today was built in 1813–14, designed by George Forder, surveyor to the Dean and Chapter, and paid for by public subscription. The mill thrived during the Saxon/medieval period, with the Domesday survey of 1086 recording that it had made a rent of 48s, placing it as one of the most profitable in the country. However, with a succession of bad harvests and the Black Death in 1348 decimating the population, the mill's importance began to decline. In the late fifteenth century, when Calais became the leading port for exporting wool, the city's economy greatly suffered, and by 1471 the mill had become semi-derelict.

With the Dissolution of the Monasteries, ownership passed from nunnery to the Crown, but was given back to the city as a 'gift' by Mary Tudor (1516–1558) in 1554; partially as repayment for the cost of her wedding in the cathedral, but also in answer to the city's plea for financial support. The city did attempt to repair the building, which thereafter was referred to as the 'City Mill'. In 1743, after nearly 200 years of neglect, the mill building that we recognise today was rebuilt by a new tenant, James Cooke, although many of the structural timbers date to the fourteenth and fifteenth century. A 1795 sketch by J. M. W. Turner is the first known depiction of the mill. In 1820, the City Corporation sold the mill to John Benham, and there followed a century of useful working life before the more advance technology of roller milling made the older stone grinding method redundant in the early 1900s.

From the First World War until 1928 it was used as a laundry. Up for sale and with the risk of demolition, a group of beneficiaries then purchased the mill, presenting it to the National Trust in 1931. Part of the building was leased out to the Youth Hostels

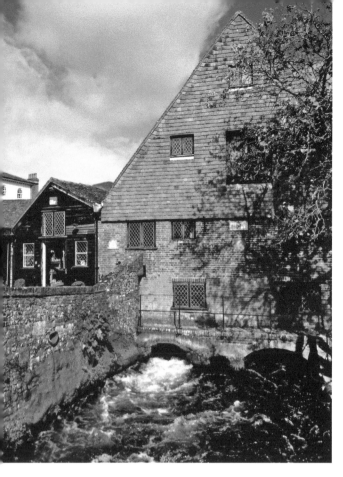

City Mill viewed from Eastgate Bridge.

Association, becoming the first youth hostel for the London region of the Association, part of a chain of hostels for the Pilgrims Way to Canterbury. Apparently the rather basic washing facilities resulted in prohibitory notices forbidding naked bathing in the river. The hostel acted as a sanctuary during the Second World War, at one point accommodating up to 100 people.

In 2005, following a twelve-year restoration program by the National Trust, it was again functioning as a fully working waterpower-driven corn mill, operating most weekends and on Wednesdays during the summer months. In addition, there is a shop and a small garden at the rear, where the stream divides.

26. Abbey House

Abbey House was once part of the land of the Abbey of St Mary, the former Saxon Nunnaminster. When this was dissolved in 1539, most of the buildings were demolished and the land gifted to Queen Mary Tudor to celebrate her marriage in 1554 to King Phillip of Spain. Later the land was further divided, and around 1750 William Pescod (c. 1704–1760), Recorder of Winchester, built the house, perhaps in part using materials still on site. Originally it faced away from the High Street (now Broadway) inward towards the then magnificent formal gardens at the rear, which (then as now) still included the stream that once fed the Abbey fishponds and the watermill. Pescod partly concealed the

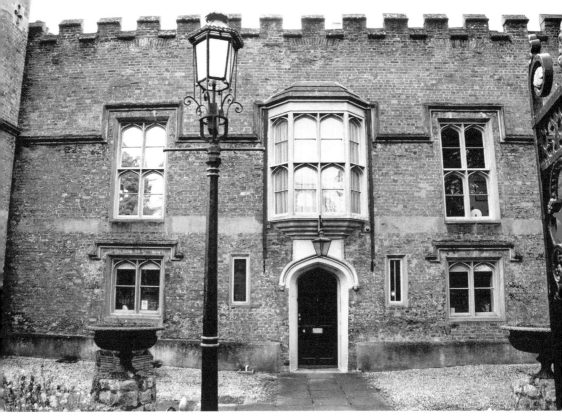

Above: Abbey House, viewed from the Broadway. The original front faced onto Abbey Gardens.

Below: Abbey House, from the Broadway.

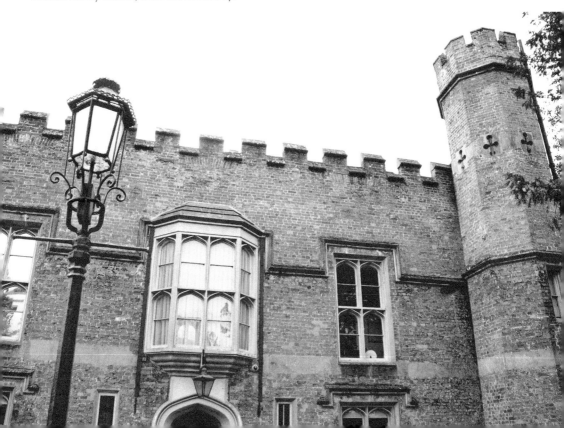

What is now the rear of Abbey House, viewed from Abbey Gardens.

mill with a Tuscan temple portico; somewhat reduced now from its former grandeur. In about 1727/28 he married Jane Harris (1706–1791), the daughter of MP, Sir Roger Harris, but she outlived him to marry again. Following his death it was occupied by Thomas Weld, and in 1771 the house was remodelled with the castellated façade added that we see today, but now facing outward, although it was not until the 1790s/early 1800s that the buildings on the south side of the High Street were demolished to make a much wider Broadway. In the 1790s, Abbey House was used as a refuge for Benedictine nuns fleeing persecution following the French Revolution, but in 1889 (the property having changed hands a number of times during the nineteenth century) both the house and grounds were acquired by the City Corporation, the latter as public gardens, and the house becoming the official residence of the incumbent city Mayor. In 1982–83, the house was extensively refurbished, restoring it to its former eighteenth-century splendour, using furniture and pictures from the city collections. It is now used as a venue for civic, community and social functions.

The office of Mayor of Winchester is the second oldest mayoralty in England, and ranks only after the Lord Mayor of the City of London in order of procedure. It probably dates to around 1190, although the first reference is in 1200. From the thirteenth century onward Mayors were chosen annually, and until the sixteenth century the Mayor-elect was required to travel to Westminster for royal assent. The first Lady Mayor, Doris Crompton, was in 1947. May 2017 saw the inauguration of the city's 818th Mayor, David McLean.

27. The Black Boy Public House

Situated at No. 1 Wharf Hill, this is a bizarre and quirky pub, which has been trading as a public house since the mid-eighteenth century. The first thing of interest is its name, which would now perhaps be considered 'politically incorrect', but the most likely explanation is it was the favoured public house for those unloading the coal at the nearby river wharf, then the upper limit of the 10.4-mile Itchen Navigation from Southampton, and which operated from 1710 until it closed in 1869, following the development of the railways. The principle cargo was coal, salt and chalk. Some cottages remain as does the Wharf Mill, the current building dating to 1885, although built on the site on an older twelfth-century mill. It was converted into apartments in 1970. At the bottom of Wharf Hill is Blackbridge, its stone arch created in 1796, and its name possibly again linked to that of the coal barges.

Originally there existed at least five pubs here: the King's Arms on Chesil Street (*c.* 1550, a pub since *c.* 1770, now the Black Rat Restaurant); The Dog & Duck (closed 1923, demolished 1937, now just a grass triangular space); The Duke's Head (closed 1905, later a laundry) and The Miller's Arms, both since demolished. Outwardly The Black Boy, while attractive and cosy-looking, belies the quite extraordinary interior: a series of individual 'snugs' and a rambling emporium of 'collectables' – bottles, books, games machines, mechanical gadgets, and taxidermy – including a baboon in a kilt, a giraffe, and two crocodiles. In the lavatories, graffiti is welcomed and doll's eyes watch you from the ceiling. This baffling interior is the inspiration of landlord/owner David Nicholson, who, after a

The Black Boy public house at No. 1 Wharf Hill.

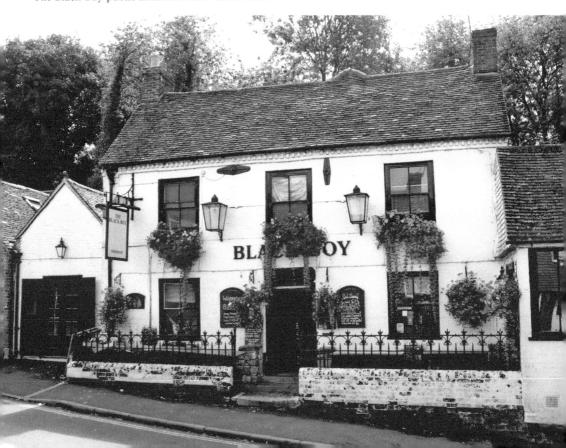

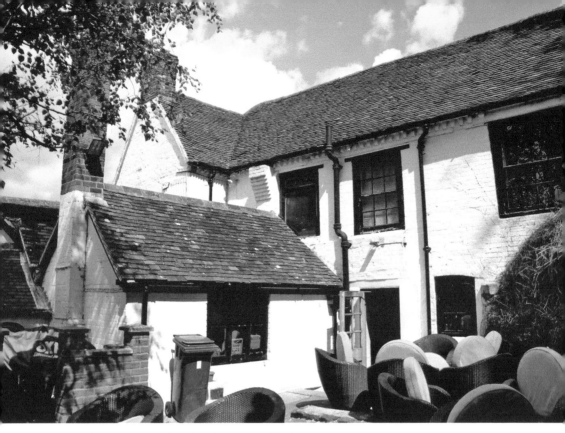

The rear courtyard of the Black Boy public house.

five-year struggle, purchased the property in 1999, establishing it as privately owned Free House. It had been operated by Courage Brewery in the late 1970s, then Whitbreads. The building we see today has seen at least seven or eight extensions from the original pub, which probably stretched no further back than the rear of the bar.

Most recently, in 2013, it extended back up the hill with the creation of The Black Hole bed & breakfast suite, which occupies the site of a former forge, acquired and demolished in 2011. The kitchens, originally behind the bar area, were re-housed in the old (once free-standing) barn, which actually may have predated the pub. Externally, dating from 2006, there is a humongous smoking shelter made of oak, again in keeping with the style of the original building.

28. No. 57 High Street

For almost 200 years No. 57 High Street was once the office of the *Hampshire Chronicle*, one of England's oldest newspaper publications. Even today the name 'Jacob & Johnson Ltd' can still be seen over the main entrance, being that of the former owners and publishers. It was Grade II listed in 1950.

On 24 April 1772, Southampton-based James Linden optimistically began publication of a weekly broadsheet, originally covering both national as well as local news, but excessive government stamp duty and tax on paper, copies sold, and even advertisements, drove him into bankruptcy by 1776. Thereafter it was moved to Winchester, in 1778, passing through

Former *Hampshire Chronicle* office at No. 57 High Street, now Zizzi's restaurant.

a succession of owner/publishers, back and forth between J. Wilkes and Thomas Blagdon (when the title was briefly changed to the *Salisbury and Winchester Journal and Hampshire Chronicle*), then Joseph Bucknell, then a printer named Long, until, between 1806 and 1812, it was printed by James Robbins, owner of the bookshop/bindery at No. 11 College Street, now P. & G. Wells Ltd. He in turn sold it to the Jacob family in 1813, and it was William Jacob, partnered with Gosport-based William Johnson from 1820, who moved the newspaper to the High Street property which still displays their names. Ultimately it was to be a combination of their business acumen, increasing both circulation and advertising revenue, together with the 1832 Great Reform Act (which reduced the crippling burden of tax), that ensured the newspaper's survival and longevity.

Although the building is probably from mid- to late-eighteenth century, the street façade we see now (with the 'Dickens period' ground-floor bow windows) is early nineteenth century, likely from after it became the *Hampshire Chronicle* office. The newspaper boasts it has never missed a weekly issue since 1776, although the actual publication day has varied over time. Like many local newspapers its format remained rooted in the past, and photographs were only included during the 1940s. It was still a family concern in the 1980s, but in 1991 Portsmouth Printing & Publishing Ltd took over the printing. It is now part of Newsquest media group (founded in 1995 and part of the US Gannett Group since 1999), and printing subsequently moved to the *Daily Echo* headquarters at Test Lane in Redbridge, Southampton. The *Chronicle* continued its connection with Winchester, however, although moving from the High Street in 2004; first to Stable Gardens, then,

in 2009, to another historic eighteenth-century building, No. 5 Upper Brook Street. This had previously been used by the *Southern Evening Echo* (both the *Daily Echo* and *News Extra* still have offices there), but long before that, until 1954, this was the Plough Inn and lodging house. Since 2005 the High Street premises has been a Zizzi Italian restaurant. The word 'zizzi' supposedly comes from the Sicilian 'zizzu', meaning 'stylish youth'.

29. Milner Hall

The sixteenth century was a dangerous time to be Catholic. One such was Lady Mary West, widow of Sir Owen West, whose name was on a 1583 list of *recusants* – those who refused to acknowledge the Protestant rite. Her house, on land once owned by Wherwell Priory, in what was then Fleshmonger Street (now St Peter's Street), became a secret haven for dissent followers of the 'Old Faith' in the 1560s–80s. It was enlarged in the 1660s by Roger Corham, who, in 1680, installed a resident priest nearby at Peterhouse. This was demolished in 1826 and is now the site of Nos 7, 8 and 9 St Peter's Street. In 1693 it was owned by Bartholomew Smith, of another 'old Recusant' family, whose son became a Catholic bishop and daughter a nun. Eventually, in 1759, the house was sold, during the tenure of Bishop Talbot, to the Catholic London District Apostolic Vicariate, one of four such which existed to uphold Catholicism in England for the period 1688–1850, and it was after this that it became known as the 'Bishop's House'. In 1795 it became the convent of refugee English Benedictine nuns from Brussels, and in 1810 it became the Convent of

Milner Hall, former St Peter's Catholic Chapel, St Peter's Street.

Glorious Assumption and a school for girls until 1857, when it was sold back into secular use to local entrepreneur C. W. Benny, previously owner of the White Hart in the High Street, who converted it into the Royal Hotel, which it still is today.

Meantime, tucked away in a courtyard on the other side of St Peter's Street was the first Roman Catholic church to be consecrate in England since 1558 (dedicated to Saints Peter, Swithun and Birinus) and opened in 1792. In 1954 it was renamed Milner Hall after its instigator, the Revd Dr John Milner (1752–1826), later Vicar Apostolic of the Midland District (1803). Appointed to Winchester in 1779, he was determined to improve facilities for his congregation, who until 1740 had still been forced to attend Mass in secret. Sometime after that date the resident priest, John Shaw, had converted a shed in his garden into a chapel, and this was extended, first by Father Patrick Savage, then by Milner in 1784, before he completely rebuilt it (largely at his own expense) in collaboration with his friend John Carter (1749–1817), architect, writer, illustrator and fellow antiquarian, and a prominent propagandist in the then evolving Gothic Revival Movement. Sadly, given its importance in both spiritual and architectural terms, the building suffered mixed fortune, not always being properly maintained, undergoing extensive repairs in 1848 and 1875, and finally being replaced by the current St Peter's Church, proposed in 1923 by parish priest John Henry Kent and built and designed by architect Frederick Walters (1924–26),

St Peter's Roman Catholic Church (built 1924–26) seen from Jewry Street.

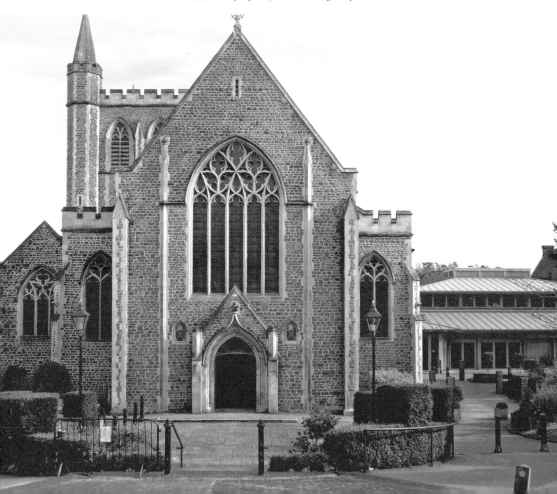

but which, in retrospect, is rather uninspired and 'typical' of late-nineteenth-century ecclesiastical Gothic. The main entrance is now in Jewry Street, and the doorway in the north wall dates from 1174, having been salvaged from the church of St Mary Magdalen Hospital on Alresford Road. The old chapel fell into disuse and neglect until 1954, when it became the parish hall, but by 1983 – having by then long-since lost its internal fittings and exterior ornament – it was just a store area, until it was rescued and restored in 1986–87 by Canon Nicholas France and architect James Lunn Rockliffe of Pinke, Leaman & Brown of Winchester. The heavy black door from the street archway was replaced by a wrought-iron gate in 1989, thereby allowing a glimpse to the passing pedestrian of this still hidden but delightful architectural gem.

30. 'Jane Austen's House', No. 8 College Street

This house could easily be overlooked whilst walking past the impressive Winchester College façade, until you see the 1956 blue plaque above the door, put there by Esmond Burton: 'In this house Jane Austen lived her last days and died 18 July 1817.' Her stay at No. 8 College Street was arranged by childhood friends – widow Elizabeth Heathcote and her sister Alethea – after Jane's health had begun to deteriorate early in 1817; the family having been advised to seek the leading surgeons of Winchester Hospital, specifically Giles King Lyford. Jane and her sister Cassandra moved into their lodgings in May; Jane describing it in a letter to her nephew as 'very comfortable. We have a neat little Drawing-room with a Bow-window overlooking Dr. Gabell's garden.' Dr Gabell was Warden (Headmaster) of Winchester College (1810–23) and his house was next door. In the 1990s, one scholar was allowed a private view of the three-storey house, describing it as full of small, bright, quaint rooms; the 'neat little Draw-room' being rather cosy, measuring only 6 feet by 12 feet, and composing of a low ceiling, bow window, fireplace and a narrow doorway, and a pretty flower and vegetable garden at the back which would not have been there during Jane's time.

The cause of Jane's death is still unknown, with theories ranging from Hodgkin's or Addison's disease, to bovine tuberculosis and even arsenic poisoning; perhaps from medicine Jane was taking to treat rheumatism. On 17 July Jane's health worsened and Mary Austen (brother James' wife) wrote that, 'Jane Austen was taken for death about ½ past 5 in the evening'. Jane had experienced a seizure. Mr Lyford, Jane's doctor, believed a blood vessel had ruptured inside Jane's head and (given the medical science at that time) made an unsuccessful attempt to remedy this. Jane had partially slipped off her bed and spent her last few hours with her head in her sister's lap. She was pronounced dead at 4 a.m. on 18 July 1817, aged 41. On 24 July, Cassandra observed her sister's funeral cortege from the same bow window where her sister used to sit and watch the world go by. Jane was buried in the north aisle of Winchester Cathedral with only four people present at her funeral. Her tomb can still be visited today, but the house is a privately owned by Winchester College and until very recently there was a notice in the front window warning off would-be visitors.

Interestingly, there has been speculation if Jane actually died at No. 8. Mrs Mary David, then aged 57 (d. 1843), was the landlady of at least Nos 8, 9 and 10, and later bequeathed No. 8 to her nephew, Frederick La Croix, pasty-cook and confectioner. Although No. 8 is the only house on the south side with a bow window, there were once six properties

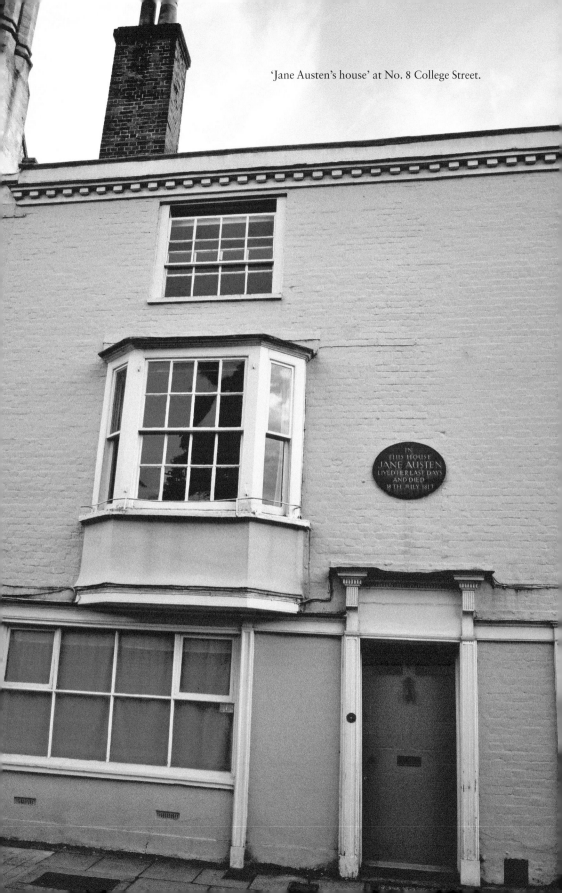

'Jane Austen's house' at No. 8 College Street.

opposite, Nos 4, 5 and 6 being pulled down in 1913–14, Nos 1–3 being demolished in 1934. No. 4 had a bow window. Firstly, Gabell's garden was on the north side, opposite No. 7, hidden behind an 8-feet brick wall, thus could not have been easily seen from No. 8. Secondly, it was not until 1891 that the first commemorative plaque was positioned by College bursar Thomas F. Kirby, 'a dour querulous solicitor' and something of a reactionary in College affairs. In 1934, Headmaster A. T. P. William wrote 'Kirby had put the tablet on the house where it is now without inquiry into the facts.' Lastly, Joseph Wells (1822–1890), patriarch of P. & G. Wells) said family tradition had it Jane died in a house on the north side with an oriel window, and a 1838 drawing showed just such a property opposite the bookshop. Thus there is room for uncertainty – from her own letters and recollections of relatives – and the house in which Jane died may actually have been No. 4 instead!

31. The Old Goal, Jewry Street

Jewry Street acquired its name from the Jewish community which expanded from two families in 1148 to some ninety Jews (out of a total population of 8,000) by the mid-thirteenth century, before being expelled by Edward I in 1290. There has been a prison on or near this site since 1228, but in 1805 a new model prison was constructed on the west side of the street, stretching back to Staple Gardens, designed by George Moneypenny (1768–*c.* 1830), whose 'house of correction' designs, like that of his predecessor William Blackburn, earned the accolade *terrific*, as in 'to strike sublime terror in the beholder'. Set

The former nineteenth-century prison building in Jewry Street.

The Old Gaolhouse is a JD Wetherspoon pub.

back behind high walls, railings and a central gateway, the ground plan appears to show a 400-feet-plus street frontage, with women debtors (sub-dived into 'common' or 'master' categories) and felons housed either side of a kitchen/wash-house and parlour central block, which also comprised the Governor's House (now The Old Goalhouse, a JD Wetherspoon public house), and the cells and exercise courtyards for more felons (presumable exclusively men) behind, with two walled-off courtyards and a small chapel separating them. It had cost £10,000 and the outward appearance was likened to that of George Dance's Newgate Prison in London (1770–80). The street name was at one time briefly changed to Gaol Street (one source says in the seventeenth century, but probably later) but reverted back to Jewry Street around 1830. Despite an 1817 Committee of Enquiry criticizing the building for being 'too handsome', it remained in use as the County Gaol until the new five-spoke radial plan prison (now category 'B' HM Prison Winchester) was constructed on Romsey Road, 1849–50, initially designed by Charles Pearce, but after he was dismissed, completed by local builder Thomas Stopher the Elder (c. 1802–74). The old site was then sold off in plots. 'Embedded' within the former gaol is the Congregational Church (now United Reform) which dates from 1853, in Early English gothic style by architect W.F. Poulton, of Poulton & Woodman, Reading. The surviving Jewry Street buildings were Grade II listed in 1950.

32. The Old Corn Exchange

Following on from civic and ecclesiastical governance and learning came commerce, and although undergoing several centuries of decline – following disasters like the Black Death, the Dissolution and the Civil War – by the nineteenth century Winchester was again becoming prosperous. Designed by local architect Owen Browne Carter (1806–1859), costing about £4,000, and opened in 1838, the then Corn Exchange in Jewry Street reflected this new mood of confidence. On the 1897 OS map it is still marked as a 'corn exchange', with cattle market behind; however, from 1906–14 it was converted into a roller-skating rink and sports hall, then a theatre in 1915 called the Empire Corn Exchange; soon renamed the Regent Theatre (managed by the Simpkins brothers, James and John), before becoming a cinema in 1917 (the Regent Picture Theatre), complete with restaurant, tea lounge and daily orchestral performances. That closed in 1922 and it was briefly the Regent Dance Hall, before resurrecting into the Regent Cinema from 1933–36, when the city spent £3,100 converting it into its last incarnation, as a public library. They had already purchased the building in 1913 for £8,000. Previous city libraries since 1850 had been in the Governor's house in the Old Gaol, Jewry Street, then the Old Guildhall in the High Street in 1873, and lastly on the corner of High Street and Colebrook Street in the new Guildhall from 1876, this having a public reading room. The existing library opened in October 1936, and a separate children's library was opened in 1953 in the two shop units then just north of the entrance. The library was remodelled in 1964–65 (under Sir Hugh

The Old Corn Exchange in Jewry Street is now Winchester Discovery Centre and Library.

Casson, costing £33,000, when the street façade reverted to its original design), and the interior was gutted and refurbished in 1976–77, when the first floor was added. Second World War air-raid shelters and tunnels still exist under the side car park, which can be accessed by metal trapdoors. It was further adapted and extended in 2006–7 by Alec Gillis and Martin Allun (Hampshire County Council) and re-named the Discovery Centre.

This is still a civic building of grandeur. It would seem that Carter drew inspiration from several different sources – the low-pitched overhanging roof and portico perhaps taken from Inigo Jones's St Paul's Church in Covent Garden; the (then popular) Italianate tower and fashionable yellow bricks from Prince Albert's Osborne House – but nevertheless the end result is extremely pleasing and harmonious.

33. The Pagoda House

Richard Andrews (1798–1859) was Southampton's own version of Dick Whittington. Born at Bishop's Sutton, Alresford, of humble origins, he became one of the wealthiest men in the south of England; coach-builder (by royal appointment), philanthropist, reformist Liberal politician and four times Mayor of Southampton (1849, 1850, 1851 and 1856). In 1844 he purchased a plot of former army (later railway) land in St James's Lane (then called Barnes Lane) and by around 1850 had constructed the Pagoda House (alternatively known as Bethsaida Lodge or Hong Kong Cottage). It was an extravagant three-storey folly in the once fashionable Chinese style built over a single-storey lodge, the upper storeys timber-framed hung with slate cladding, and with a trelliswork balcony dominating the first floor. He purchased the two terraced Regency (c. 1835) houses next door for guests. In 1851, the year of the Great Exhibition, the house featured in the *Illustrated London News*, being described (in the parlance of that time) as 'the cottage of the mayor of Southampton' and the accompanying drawing showed two Chinese encased chimneys with finials, curved dragon heads on the balcony roof, together with a fountain in the garden. A *Telegraph* article (2001) by Alexander Garrett gives more detail, Alderman Andrews having invited the Hungarian nationalist hero Lajos Kossuth (1802–1892) to visit and give a speech. Also mentioned is the Italian Giuseppe Garibaldi (1807–1882) and a more mysterious, and unidentifiable 'Polish dissident Count Czarski', of whom we can find no record, unless he is the then very elderly *Prince* Adam Jerzy Czartoryski (1770–1861).

In 1854 Andrews sold the house to his son Albin Adams, and built Lucerne Villa (in the Swiss chalet style) at nearby Kerrfield, since demolished. By 1858 the house was owned by Harriet Cameron Smyth and Colonel Ralph Smyth (ex-East Indian Company), the name being changed to St George's Lodge or House. Following Ralph's death in 1886, his daughter Harriet Maud married William Edward Baker. Alterations were made between 1874 and 1914, changing the roofline and original L-shape plan, with further additions made in the 1920s and '30s, before being bought by the City Council in 1936 and converted into three flats, at some time used by Water Board employees. The nadir came following the Second World War when it was used for returning servicemen, and later as Council bedsits. In 1970, then still owned by the city and having failed to sell by auction, Peter Hitchins and his wife Patricia managed to raise 10 per cent of the asking price of £14,000 and bought it to be used as a tutorial college for teenagers excluded from mainstream schools. Peter described it as having been 'divided up using lots of stud walls into grim little flats that were

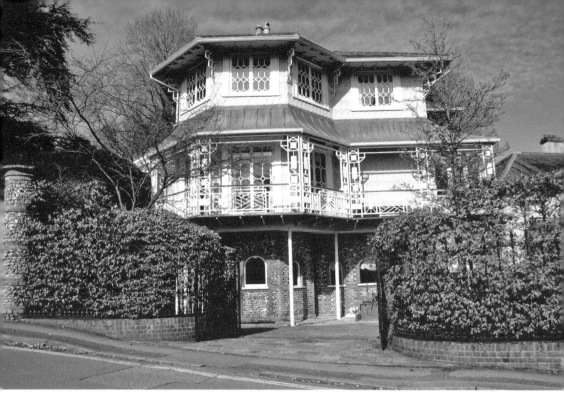

The Pagoda House in St James's Lane.

in a disgusting state', but which they lovingly restored over the next two years, until they sold it in 1972, moving to Symondsbury Manor. Next, Denis and Catherine McLaughlin purchased it for £32,000, and in 1976 Dennis wrote a seventy-page dissertation on the house for the Open University. Later, in 1983, Tom and Veronica Carter, who had apparently originally wanted to buy it in 1972, bought it for £95,000. Tom, formerly a language professor at Southampton University, was himself of Polish and Italian extract, the family name being Kantorowicz. They too made restorations and improvements, including adding a swimming pool and sauna, using it as a family home while letting out the ground floor to students. It was during their tenure that the house was Grade II listed, in 1988. They eventually sold in 2001, by which time the price had increased to £895,000. The new owners, Mr and Mrs Gatenby, also made extensive repairs and improvements, together with local historic building architects the Radley House Partnership, restoring lost features, remodelling the garden and acquiring an area of adjoining land for a garage and folly. In 2016 it was again on the market, the sale price being between £3,950,000 and £4,500,000. It was described as having six bedrooms, music room, drawing-room, dining-room and study, orangery, morning and afternoon conservatories (in all 5,000 sq. ft of living space over three floors), and 2–3 acres of 'romantic gardens'.

34. The Theatre Royal

Built in 1850 by Henry Vaughn, dismissed as 'a scamping speculative builder' by Thomas Stopher the Elder (although possibly designed by O. B. Carter), the now magnificent Theatre Royal began its life as the thriving Market Hotel; a convenient and popular inn for

farmers wishing to trade at the Corn Exchange next door (now the Winchester Discovery Centre). Its grand size and design represented its popularity as a hotel. However, having been acquired in 1912 by brothers James and John Simpkins, it was extended further into the yard and opened as a 'cine-variety' theatre in 1914. The Arthur Lloyd website (www. arthurlloyd.co.uk) suggests that the auditorium was designed by local architect Bertram Cancellor, and *not* F. G. M. Chancellor, as stated elsewhere. Now named the Theatre Royal, it saw mixed nights of melodrama with premiers of silent films, and even performances by Chesney Allen and (in 1915) Gracie Stanfield (1898–1979, before her stardom as Gracie Fields). With moving pictures growing in popularity, it became exclusively a cinema in 1920, sound being installed in 1928.

After John's death (in 1923), brother James sold out to Country Cinemas Ltd, later the Odeon cinemas until 1950, although they became part of the J. Arthur Rank Corporation in 1938. It was run by various lessees from 1953 until 1974, when its future was under threat after the then owners, Star Group, closed the theatre and applied for a demolition order, intending to sell it for redevelopment as a supermarket to Bejam (now Iceland Group). Fortunately Winchester City Council intervened, and a Grade II listing was secured. Within two months the Winchester Theatre Fund was born, ready to 'restore live theatre in Winchester'. By 1977 enough money had been raised to purchase the Theatre Royal for £35,000, as well as the two adjacent buildings (Nos 22–23) later the following year. In 1987, with the purchase of a projector, the theatre saw its second incarnation as a 'cine-variety'. Ten years later it closed for restoration. A proscenium arch was added and original

The Theatre Royal in Jewry Street.

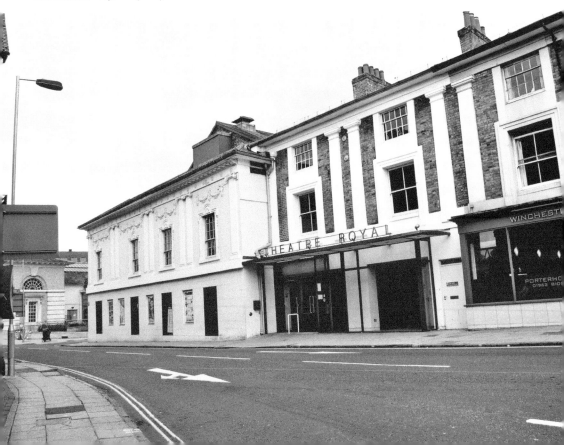

plasterwork in the auditorium restored, ensuring it remained sympathetic to its period. A modern twist was added, however, through the addition of a contemporary curved wall (even though its glass sections were based on the west window of Winchester Cathedral); the architect was Burrell Foley Fischer. It reopened in 2001, once again the pinnacle of creative arts, and is now run by the Live Theatre Winchester Trust. Theatrical ghosts include a dancing girl, a Victorian lady, John Simpkins himself, seen walking from where his office once was, and, during the First World War, a soldier in combat uniform, later identified as one of the spotlight operators who had died that very night on the Western Front.

35. King Alfred's Diocesan Training College

The King Alfred's Diocesan Training College is one of the earliest teacher training colleges in the country, although not always located at its current site on West Hill. Originally the brainchild of Charles Richard Sumner, Bishop of Winchester (1827–69), it first operated from a house in St Swithun's Street (1840–47), then moved to Wolvesey Palace (1847–62), but was forced to move again due to space constraints and damp problems. The building we see today was constructed on land donated by the Cathedral Dean and Chapter, and built by John Colson (1820–1895), who incorporated Third Empire fashionable elements such as stone sphinxes. Construction cost £7,450 and it opened in October 1862. The original design had the Principal occupying a five-bedroom attached house at the east end, his Deputy at the west end, the students between, and lecture rooms on the ground floor, thus rather reflecting the

King Alfred College is now an administrative building for the University of Winchester.

Above: King Alfred College chapel, now part of the University of Winchester.

Right: The gold extension to the chapel.

then stern nature of the College. It was designed to encompass fifty-six students, but it evolved into King Alfred's College (in 1928) and subsequently Winchester University, having by 1993 over 3,000 students, while in 2017 the number had increased to 8,000. Rules remained strict for the students, being only allowed to walk on the gravel and not the grass, but even back then they would still play pranks, one traditional such student prank being to paint or remove the stone sphinxes on the terrace! Contemporary students now find similar enjoyment by stealing the bird from the statue of St Francis and replacing it with saucy and vulgar substitutes.

In 1881 the chapel was constructed on the western edge of the ridge by Mr H. Macklin, and designed by Messrs Colson & Son of Jewry Street, as a memorial to Bishop John Utterton, who had died suddenly whilst administering Holy Communion in Ryde Church in December 1879. It was instructed that the chapel had to 'harmonise in design with the school' and was erected entirely by private subscription, costing around £1,000. It was furnished by gifts, including two small stained-glass windows from former students, and all service books and the bible were provided by the Society for Promoting Christian Knowledge (SPCK). The chapel was extended in 1927 to cater for an increase in teacher-training students, as visiting was compulsory. With the introduction of women students in 1958, plans were made for a new modern circular chapel, opened in 1964. The original chapel was threatened with demolition, but this was fiercely opposed by the Winton Club, as it housed their memorial for those fellow students lost during the two world wars. Eventually an internal dividing wall was added to preserve the memorial room, permitting a small chapel with the original altar, organ and east windows. In 2015, as part of the University of Winchester's 175th celebrations, the old chapel was fully restored, together with the addition of a new shiny golden side-chapel extension, designed by award-winning Design Engine. The 1960s chapel is now the Kenneth Kettle IT centre, named after the honorary secretary who first advocated the introduction of women students.

36. Royal Hampshire County Hospital

The existing Victorian building was not the first county hospital in Winchester, but the third. First came 'The County Hospital for Sick and Lame at Winchester' in Colebrook Street, built in 1736 by Dr Alured Clarke (1695–1742), housing just sixty in-patients in an old previously rundown medieval property. It is said to be the first of its kind outside of London. Clarke's second attempt was to then adapt a mansion on Parchment Street, formally known as Clobury House, made possible by the death of Richard Taunton (millionaire and twice Mayor of Southampton) who bequeathed £5,000. This second hospital was completed in 1759 and had space for 128 patients, under-floor vents to improve air quality, and even its own water supply! Unfortunately, this became contaminated in 1835 and caused a cholera outbreak. Because of problems with sewers, in 1859 Florence Nightingale campaigned for Winchester's hospital to be moved, and in due course, in January 1862, the Committee appointed by the Court of Governors submitted their proposal for a new hospital to be erected on the south side of Romsey Road, and a 5.5-acre site, 'unrivalled in the salubrity of its situation', was purchased the following year.

Given the scale of the project, the Committee chose William Butterfield (a Gothic Revivalist 'architect of first rate eminence', 1814–1900), but his plans to be overseen by Miss Nightingale. They soon fell into disagreement; Butterfield wanting dayrooms for

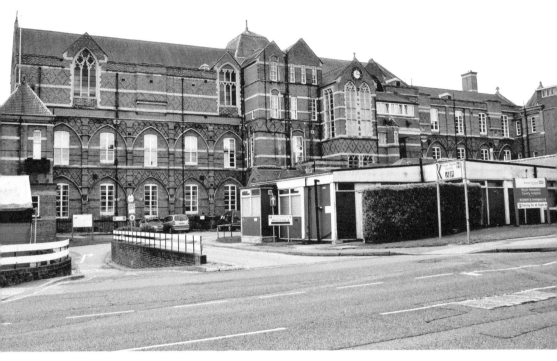

Above: Royal Hampshire County Hospital in Romsey Road.

Below: A rear view of the Butterfield Wing at the Royal Hampshire County Hospital.

the patients which she thought unnecessary; he planning multiple small wards, while she believed larger wards allowed patients to be seen easily. One lasting Victorian belief-system was in the treatment of venereal disease, regarded as God's 'punishment' for sinful acts. The Sexual Health Clinic is still kept separate. The outcome of these consultations was a building that took five years to complete and cost £24,713 1s 11d (another £1,430 for the chapel, £500 denoted by Butterfield), consisting of a central 255-feet-long block, 3/4 storeys high, with two wings, a capacity for 108 in-patients, a lift, and the capacity to grow its own fruit and vegetables – but still not getting proper sewerage till 1897! An annual subscription of £100 was sanctioned by Queen Victoria with the command that the hospital henceforth be styled Royal.

Capacity became an ongoing problem, and in 1959 it was suggested demolishing Butterfield's building, but eventually financial constraint (rather than sentiment) meant it survived, converted into the Butterfield Wing, although by 2014 this was in part empty, being 'unfit for clinical use'. A maternity unit was opened in 1973, while in 1986 Nightingale Wing (A&E) was opened, with Brinton Wing added in 1992. In 2012 the Winchester and Eastleigh Healthcare NHS Trust merged with Basingstoke and North Hampshire, creating Hampshire Hospitals Foundation Trust. However, with the pressure of spending cuts, together with limited space and ageing infrastructure at the Royal Hampshire County Hospital, plans are being made to build a new multipurpose hospital between Winchester and Basingstoke, near junction 7 on the M3. The future looks uncertain, although the University of Winchester has already purchased some former hospital land.

37. The Guildhall

From the time of Saxon King Alfred the Great until that of Henry VIII, the land between the High Street (now Broadway) and Colebrook Street was given over to the Nunnaminster, founded by Ealhswith, Alfred's wife (sources say in AD 903, although she actually died in 902). It was rebuilt and rededicated as a Benedictine nunnery around AD 960–963 by Bishop Æthelwold, and, after the Norman Conquest became the Abbey of St Mary and St Edburga (Alfred's granddaughter, whose father was Edward the Elder). Following the Dissolution in 1539, the abbess and her nuns were granted a pension and many of the buildings were demolished, with the land passed to the Crown. Broadway itself is an early nineteenth-century creation, with various sources saying the range of houses on the south side, then owned by Thomas Weld, and backing onto what is now Abbey Gardens, were pulled down either *c.* 1798 or 1802, although still shown on a map by J. Cave and J. Milner dated 1809.

After several centuries of civic decline, Victorian Winchester was again on the ascent and the most enduring symbol of that period was the new Guildhall, designed by Hastings-based architects Alfred Wilson Jeffery (1840–1915) and William Skiller (1838–1901) in a flamboyant French-Gothic style, not unlike the cloth halls of Bruges and Ypres in Belgium. It cost £10,313, with the rear extension (1875) costing an extra £4,837; the foundation stone was laid in December 1871, and it was opened by the Lord High Chancellor, Lord Selborne, on 14 May 1873. The symmetry of the street façade was lost with the additional, rather plain, extension in 1892–93, designed by surveyor of the cathedral, John B. Colson (1820–1895). Originally the city library and School of Art, this necessitated the demolition of the old fire station and police station (built in 1800) on the corner of Colebrook Street. The Guildhall was renovated in 1971 and was Grade II listed in 1974.

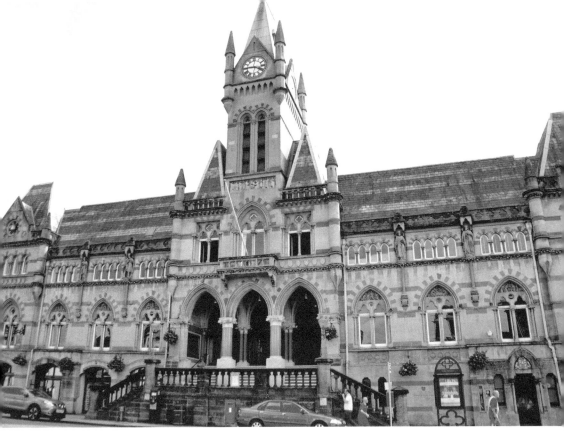

Above: The Guildhall viewed from Broadway.

Below: The Guildhall viewed from Abbey Gardens.

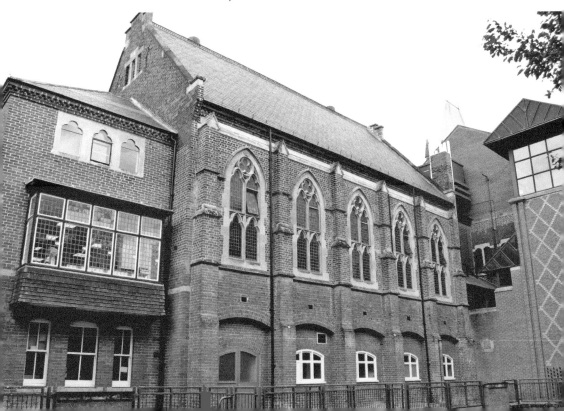

38. West Downs College

West Downs College was originally the Winchester Modern School, a small prep school with only four students. It has not always been as successful as its subsequent reputation may have you believe. This college was built around 1880 and financed by the Liberal politician and reformer Thomas George Baring (1826–1904, 1st Earl of Northbrook, Viceroy of India 1872–76, First Lord of the Admiralty 1880–85). In 1897, Lionel Helbert leased the building on the West Hill site and improved on its success after two failed attempts, managing to increase pupil numbers to sixty-five by 1907. Expansion continued thereafter, so that nine years later the school acquired Melbury House, which is now the Masters' Lodge. Although Helbert died after the First World War, the college continued to prosper under headmaster Jerry Cornes, Olympic Silver Medallist, until its closure as the Winchester Modern School in 1988. Notable alumni include two of Churchill's sons-in-law, Duncan Sandys and Christopher Soames, Jeremy Morse, former Chairman of Lloyds Bank, naturalist Sir Peter Scott and Oswald Mosley, 1930s leader of the British Union of Fascists, who also attended Winchester College.

After several years of neglect and vandalism, in 1995 West Downs was in a dilapidated state when the 12.5-acre site was bought for £4.5 million by the University of Winchester. As part of the agreement for planning permission for the new student village, they were to subsequently restore the old school buildings. In fact this restoration cost more than the original purchase price and nearly bankrupted the University. It took four years, and a budget of £16 million, to construct the award-winning halls of residence, designed by

West Downs College in Romsey Road, now Winchester University.

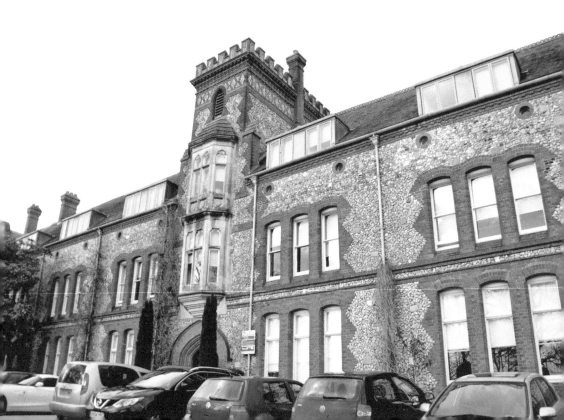

West Downs College, viewed from the rear.

Fielden Clegg Bradley, situated on the school's old sports field. Finances were so tight that when the site steward caught (as yet unpaid) subcontractors removing copper tanks and plumbing, the driveways were blocked off. In 1998 work began on the college building itself, opened as an arts centre in 2001 by David Terrence, Lord Puttnam of Queensgate, followed by what is now the Winchester Business School in 2011. Inside the building, the original red brick can still be observed, integrated within modern glass and sculpture. Melbury House was the last to be updated (now the Master's Lodge), which was designed by John William Simpson, who later designed the Wembley Football Stadium towers.

Expansion and renovation continues at the time of writing, with further plans submitted for a new university 'public realm' to be completed by September 2019. Begun in 2017, this will consist of an 8,000 sq. ft centre with shop, café, library and lecture halls, and with the same award-winning roofline as the University Centre, itself designed by Design Engine. Also included will be a circular weathered steel lecture theatre, intended for public events such as talks and conferences, thereby bonding the University closer to the local community.

39. The City Museum

The City Museum, at the junction of Great Minster Street and the Square, is perhaps an appropriate place to contemplate just how different was the past to the refined, chic and rather genteel retail and restaurant locality we see today. From medieval times until the nineteenth century this was the city's meat market, with slaughterhouses nearby. Where the Museum is now was once the Market Hall, a two-storey building with a frontage of

stone pillars and arches, the open ground-floor having stalls and slaughtering facilities, the adjoining streets only being paved and a fixed pump installed (to 'cleanse the shambles twice a week') in 1760. The Square had long been a site of public executions, but near here too, for centuries, was located the town 'cayge' and pillory, for the more fortunate malefactors. Amidst the chaos, noise, blood and smells, the large upstairs rooms were hired out to touring theatre companies until the first new, more permanent Jewry Street theatre was built in 1785.

In 1837 this building was replaced by the Mechanics' Institute, 'from the design of Mr. William Coles', and 'in the Tuscan order...supported by piers and columns, the space below being [still] occupied...as the Butchers' Market.' An 1840 article described it thus:

> There are two approaches to the Institute, one from the Square and the other from the Cathedral yard, which lead by a commodious staircase to an elegant Lecture Room, 40 feet long, 22 feet wide and nearly 20 feet in height, arranged with elevated seats which will accommodate from 250 to 300 persons. Adjoining is a Library and Reading Room and over it a Museum.

The butchers' market finally closed in 1855 and the ground floor was used as reading rooms. Despite the Winchester Technical Institute spending almost £800 on improvements, the lease neared its end in the 1890s and, in 1903, the Corporation commissioned the current building, constructed on the pre-existing foundations, as a purpose-built museum, possibly the first such in Hampshire. This was in the then fashionable Tudoresque design, of stone and flint, and regarded by some as not really in keeping with other buildings nearby.

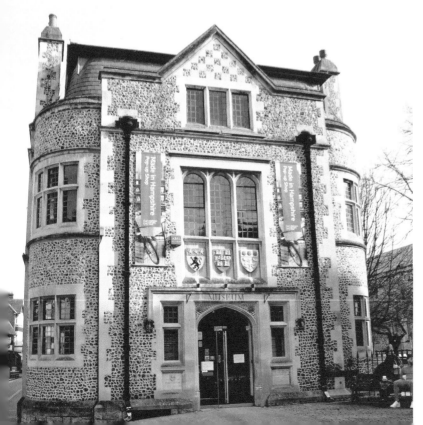

The City Museum in The Square.

Grade II listed in 2002, it was closed for a £155,000 extensive roof refurbishment in 2006. Since 2014 the Museum, together with Westgate and the Gallery at the Discovery Centre, have been operated and funded by Hampshire Cultural Trust. It was closed briefly again in early 2017, and is now the permanent home for the 15-feet wide model of Winchester in around 1870, painstakingly constructed over nine years by retired former County Planning Officer, Roger Brown (d. 2015), using old photographs and the first detailed OS 1873 map.

Between 2005 and 2012 the City Council, together with Hampshire County Council and local businesses, funded the innovative painted artwork on a total of twenty-one cast-iron bollards in and around the Square. The designs, undertaken by The Colour Factory workshop (based in Gordon Road), reflect both the city's history and works by famous great artists.

40. Romsey Road Guardhouse and AGC Museum

The Romsey Road Guardhouse was built around 1903 by Edward Ingress Bell (1837–1914) using cheap bricks and reused stone of the portico from the King's House after it burnt down. Scorch marks can still be seen on the end pillar, as well as bayonet-carved graffiti made by bored sentries. Located at the rear were originally six cells, an ammunition store, and two open-air enclosed exercise yards in which troops could be confined up to twenty-eight days for offenses which did not merit military prison, such as disobedience or drunkenness.

Romsey Road Peninsula Barracks Guardhouse and AGC Museum.

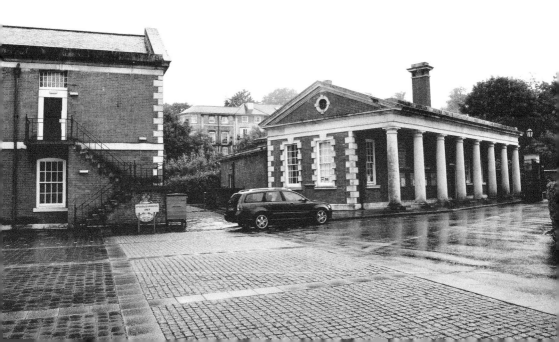

Although the army pulled out in 1986 (thereby ending almost 2,000 years of military presence on this site), the Ministry of Defence and Crown Estate retained and renovated a number of barrack buildings as museums. These are The Royal Green Jackets/Rifles Museum; the Gurkha Museum/King's Royal Hussars (HorsePower) in the Short Block, facing Peninsula Square; and the Adjutant General's Corps (AGC) Museum, opened in November 2003 by Her Majesty the Queen. During refurbishment the exercise yard was roofed over, and the entrance (originally nearest the main gate) has now been centrally relocated, leading also to the site Visitors' Centre and Copper Joe's Café, itself integral to the exhibitions. The AGC was formed in 1992 from the merger of the Royal Army Pay Corps, Royal Military Police, Military Provost Staff Corps and the Education and Legal Corps, while the museum also reflects the role of women in the army since 1917. One of the exhibits is the War Department driving permit used by a young Princess Elizabeth during the Second World War. There was originally a platform located in the adjacent railway cutting, accessed through a tunnel under the Guardhouse that enabled troops to embark trains to Southampton as well as discreetly moving the wounded to the barracks' hospital facilities.

41. Former King's House and Winchester Barracks, Castle Hill

After the Restoration of 1660, Charles II looked to create a summer residence 'sufficient to entertain the whole court with all kinds of sport and diversion' in the Royalist stronghold of Winchester, as an alternative to Windsor. Sir Christopher Wren proposed replacing the old medieval castle (slighted by Oliver Cromwell) with a completely new palace, designed to rival the splendour of Versailles. Having visited the site in March 1683, Wren began

Long Block, facing the site of the former King's House, later Winchester Barracks, in Peninsular Square (now private apartments).

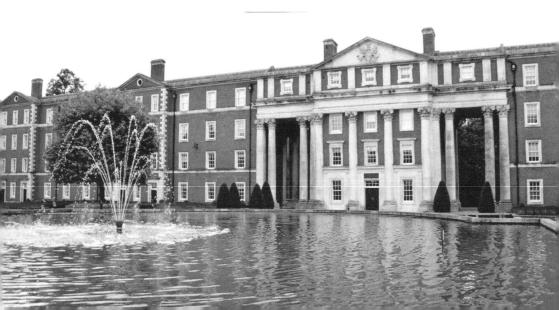

work on the main brick building, which had a central portico of elaborate pillars (carved by local stonemason Edward Strong), together with flanking wings, forming three sides to a magnificent piazza-like courtyard. As part of this grand vision, the Crown purchased land between the castle and the cathedral, intending to construct a magnificent 200-feet wide avenue between the two, which would be lined by houses for the nobility and persons of rank.

Charles himself had laid the foundation stone on 23 March 1683, and exclaimed, 'If it be possible to be done in one year, I will have it so, for a year is a great deal in my life.' This proved true as he died in 1685, the palace unfinished, and, despite £45,000 already spent and only the shell complete, James II halted the project. Instead the palace become the residence for only two watchmen and their dog, neglected and derelict, and later (1757–64) becoming a prison for up to 5,000 French soldiers during the Seven Years' War, and again during the American War of Independence (1778–83, with over 6,000 French and Spanish). From 1792–96 the King allowed the building to be used as a refuge for refugee clergy fleeing the French Revolution. Finally, in 1796, the War Office acquired the building as a permanent barracks, overriding George III's previous objections.

By 1809, however, the King's House was once again 'fast in decay' and £73,000 was spent on an extra floor within the state apartments, allowing total accommodation for 1,700 men. For the rest of the nineteenth century it was one of the principal depots for the British Army, until devastated by fire on 19 December 1894, and subsequently demolished. However, Wren's stone columns were incorporated into Edward Ingress Bell's Guard House portico and that of the new Long Block. The Prince of Wales laid the foundation stone in June 1899 and the barracks were completed in 1904. The footprint of the old palace vanished beneath the Short Block, Junior Ranks Club House, and then parade ground; the Long Block constructed on the former castle ditch. The 1856 Officers' Mess towards St James's Lane was demolished and rebuilt in 1962, but that too has since been replaced with something more in keeping with the overall style. The Rifle Depot was here from 1855, later the Green Jackets Depot in 1951, before the Light Division Depot eventually moved to the Sir John Moore Barracks outside the city (formerly RAF Flowerdown) in 1985, thereby ending any army presence within the city. Thirty years later, the derelict buildings have all been refurbished and converted into top market residencies, with a two-bedroom flat selling at £625,000 (as of June 2017).

12. WHSmith, Parchment Street

In an exceptionally lengthy and interesting High Street, with so many buildings of different periods and architectural styles, one might perhaps be forgiven for barely noticing the WHSmith bookshop and stationers on the corner of Parchment Street. And yet it merits closer attention, even of the side exterior. For at least some of the twentieth century, from the High Street along Parchment to George's Street, this was once divided into separate units. What is now the main post office (itself once in Middle Brook Street, and since 2008 operated under the WHS franchise), was formerly the site of a warehouse and garden, later (from 1816) a Wesleyan chapel, then in 1867 it was purchased for the sum of £350 by the Freemasons, who used the upstairs rooms. After being sold to WHS in 1990 (for £670,000), only one exterior wall was retained, with Masonic symbols high up, although the date displayed, 'founded 1761', commemorates that of the Winchester Lodge of

Economy No. 76, one of the oldest in the UK. The Lodge subsequently moved to 'Penglyn', Alresford Road, opposite St Swithun's Girls' School, where they have constructed a unique underground temple.

From 1934 until 1979 there was a butcher at No. 2b Parchment Street, with a fruiterer/greengrocers next door at No. 2a. The rest of the building facing onto the High Street is from 1927 (again which date can be seen in the stylised lead drainpipe and cistern-head) designed in the Arts and Crafts Domestic Revival style by George Leo W. Blount (1870–1932) of Blount & Williamson of Buckingham Street, Salisbury. Exterior stonework gives way to mock-Tudor, together with displays of heraldic coats of arms, but, in general, neither this nor the interior ground floor of the shop merit anything special, although a discreet display at the shop's rear shows artefacts from a fourteenth-century house predating the chapel/Mason temple, excavated in 1991. However, proceed upstairs to the bookshop, look up, and suddenly you are transported into an amazing 'medieval' grand hall, with a high timber hammer-beam truss roof and painted moulded plasterwork. King Alfred in the Shepherd's Hut is at one end; King Arthur and the Round Table at the other, together with wonderful Bayeux Tapestry-like illustrations on either side depicting historic characters, the natural world, and even the early medieval ships known as cogs. Initially styled 'The English

WHSmith, No. 101 High Street, looking along Parchment Street.

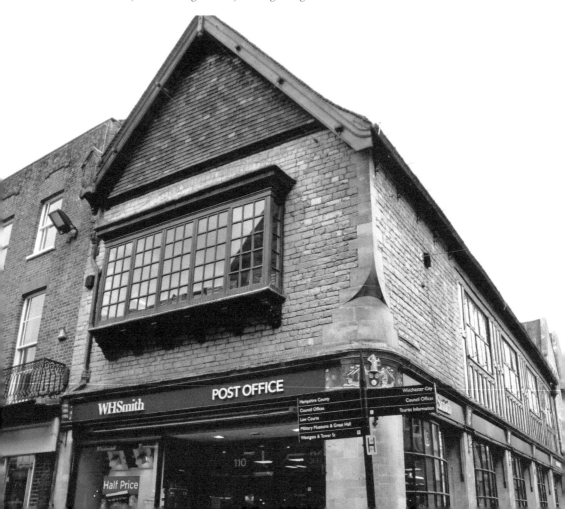

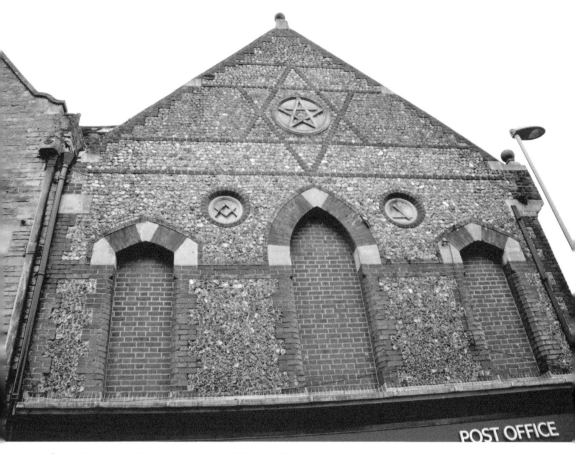

Above: The original Masonic temple building wall.

Below: The upstairs interior, former Audrey tearooms and dance hall.

Tea-Rooms', from its 1920s inception until 1966 this upper floor was listed as the Awdry Tea Rooms, later Awdry Rooms Restaurant and Club, functioning also as a dance hall, with its own exclusive access. Initially ran by WHS, by the 1940s it was part of the Fullers chain of teashops, later known as Fuller-Kunzle. The Awdry name was apparently 'after two old Wykehamists who were directors of W.H. Smith'. This would appear to be Charles Awdry (1847–1912), former student of Winchester College and Oxford, a barrister with colonial links, who was an acting senior partner 1870–1911, and his eldest son, another Wykehamist, Major Charles Selwyn Awdry (b. 1877, missing in action at Bapaume in March 1918). The elder Charles' wife, Margaret Moberly (1852–1939), was herself a Wintonian, daughter of the Right Revd George Moberly, College headmaster.

43. The Lido Sports Club

Located on the corner of Worthy Lane and Hyde Church Lane is the Lido Sports Club, originally conceived and built by Charles Francis George Richard Schwerdt (born in Münster, Germany, in 1862) of Old Alresford House – businessman, landowner and local magistrate – to help provide work for the local unemployed (although the construction company was Bierrum & Partners, London). It was opened in summer 1934, with an open-air 80-foot by 40-foot, 100,000-gallon swimming pool, at the time said to be one of the 'best equipped in England'. The land had previously belonged to the County Girls' School (now Westgate School), and was opposite the former municipal coach station in Worthy Lane. Admission was 1s for adults (9d on Thursdays), half-price (6d) for children. Water

The Lido Sports Club, Worthy Lane, Hyde.

The Lido Sports Club, Worthy Lane, Hyde. The open-air swimming pool is now a car park.

was filtered and changed every six hours. Schwerdt died in 1938, aged sixty-five, and his widow (Matilda, *née* von Guaita) sold the property to the Council for £3,500. During the Second World War it was commandeered and latterly used by the US military, only relinquished back to the city in 1945. The pool (open in the summer months) continued in use until 1969, when the new indoor pool at Winchester College was used until the River Park Leisure Centre off North Walls was opened in 1974. This was gutted by fire in 1986 and the existing Leisure Centre reopened two years later. Sadly, the Lido pool was filled in around 1978 and is now a car park. Throughout the 1950s and '60s, under the management of Reg Pragnell and his son Tony, what is now the main hall (immediately down the steps from the car park entrance) was used as a dance hall/ballroom, with many of the top pop groups from the 1960s playing there, including the Rolling Stones (December 1963; they were paid £200!), The Hollies (1964), Manfred Mann, The Kinks, The Searchers, and Billy J. Kramer, among others. Other venues included wrestling, bingo, dog shows and the pool even being used by Jehovah's Witnesses for baptisms. The original ticket office window is still there, opposite the entrance from Hyde Church Lane, although the then bar upstairs is now the small martial arts hall. In 1968 it became the permanent home of the Winchester and District Badminton Association (founded 1957). There are still two badminton courts in the main hall, but the former squash courts have been converted into the entrance hall, changing rooms and martial arts 'Dojo' room, with a children's nursery in one wing. It was purchased from the city in 1986 and has been a registered charity since 2001. If no longer a true Lido, this is still an impressive building, the exterior in a panache Palladian style more reminiscent of the early nineteenth century.

44. Hampshire County Council Offices

Hampshire County Council was established in 1889, and the administrative offices were originally located in Castle Avenue, the road being first laid out in 1895–96, leading from Westgate to the Great Hall. The buildings here date from 1891–95 (on the east side by Sir Arthur Blomfield and county surveyor James Robinson), with further additions 1912 by W. J. Taylor and Sir Thomas Jackson, and in 1931–32 by Sir Herbert Baker and A. L. Roberts. Previous to that access was from east of the city gate, up Castle Hill, past the Westgate Hotel and Tavern. In 1936 Charles Cowles-Voysey (1889–1981, retired 1955) was commissioned to design a large complex north of Westgate, between Sussex Street and Tower Street, but his design was put on hold by the advent of the Second World War. In consequence the imposing neo-Georgian (but vaguely continental-style) building now known as Queen Elizabeth II Court was only finally constructed two decades later, in 1955–59, and opened in 1960, the architects now also credited as Cowles-Voysey's later partner, John Brandon-Jones (1908–1999), together with Robert Ashton and John Broadbent. The interior was described as having 'idiosyncratic neo-Romanesque details... in a Scandinavian classical-influenced idiom' (Historic England). It was Grade II listed in 1998. The original Cowles-Voysey design had only a pedestrian entrance with steps, and an archway across the road to Westgate. The bronze pig, near the main entrance, very reminiscent of similar sculptures seen in the Netherlands and Germany, depicts *The Hampshire Hog* by David Kemp (1989).

Hampshire County Council offices, Westgate.

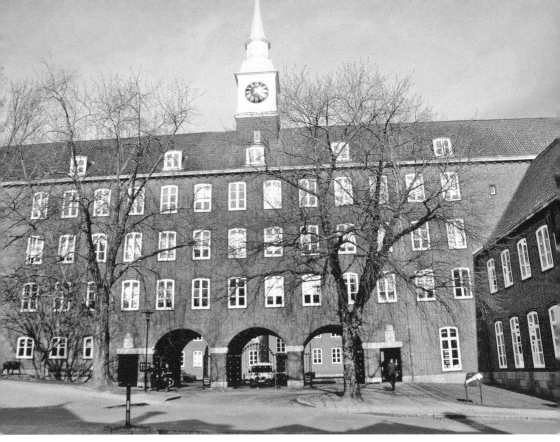

Hampshire County Council offices, Queen Elizabeth II Court from Westgate.

In 1964–66 a further expansion was 'tacked on the back', following the line of the old city wall north, and this was Ashburton Court; by contrast this was in the more contemporary modernist style, designed by the County Architect and described as a 'bland, boring and bad-mannered block of no architectural merit whatsoever' (Richard K. Morris, 1994). The 2009 Building4Change website (www.building4change.com) chronicles the County Council's recent renovation options just forty years later as being: minimum repair, costing £15–20 million; demolition and reconstruction, £75–80 million; or extensive refurbishment of 'existing frame', £42 million. They went for the refurbishment option.

45. The Rotunda, College of Art

Although the Winchester School of Art (WSA) was originally founded in 1870 and was at one time located in Wolvesey Palace, it was not until 1962 that it finally moved to its current premises in Park Avenue, off North Walls. The initial buildings were designed in 1962–66 by then County Architect H. (Harry) Benson Ansell (1914–86), previously architect for the London County Council and who also designed the Hampshire County Police Headquarters in Romsey Road (again in 1962–66, demolished in 2016–17). Rather bizarrely, it was part of requirement for planning permission by the local authority that it could be converted into an emergency hospital in the event of war; a policy, however, very soon abandoned. The Rotunda was constructed in 1964 as the School Library, a 'concrete

The Rotunda at the Winchester School of Art, Park Avenue.

and glass castle' with its 'ornamental pond' or moat fed from a tributary of the Itchen, the first floor housing a quiet room, book store, the library room and reading bays, the shelves radiating out like spokes from the central spiral staircase. It is connected by a flying bridge cantilevered over the moat to the first floor level of the rest of the main building, and the design is still very innovative and visually attractive, even now.

The WSA building was officially opened on 2 October 1966 by the Right Hon. Viscount Eccles, formerly David McAdam Eccles (1904–99, from 1962 1st Baron Eccles of Chute, Wiltshire), Conservative politician, educated at Winchester and Oxford, who was Education Minister from 1954–57 and 1959–62 (when the school project started) and later Minister of the Arts 1970–73.

In 1996 the WSA became part of the University of Southampton, and Westside Buildings on the opposite side of Park Avenue were designed by local architect Richard Rose-Casemore of Architecture plc, winning a prestigious RIBA regional award. The Library was then moved into Westside and the Rotunda became first the Visual Art Department, then the Graphics Studio, although the Library still uses the ground floor, whose storage cabinets still radiate out spoke-like as in the original design. In 2013 the Rotunda was re-roofed and new windows and a central column installed (enabling access to the roof), while the East Building, to which it is attached, was re-roofed in 2016–17. Other campus alterations in 2015 included the Student Union building being converted into a 100-seat Lecture Theatre and the café area designed and modernised. In 2017 the old police station site on North Walls was acquired, with the intention of extending the campus eastward. The Erasmus Halls of Residence are located in Easton Lane, Winnall.

46. Combined Law Courts, the Castle

In 1871 the Anglo-Irish architect Thomas Henry Wyatt (1807–80) was engaged to construct new Assize Courts linked (by a series of arches) to the Great Hall (which was also to be restored). The new building – designed in a sort of late medieval 'baronial' style – was built in 1873–74, extending east over the former castle ditch. Unfortunately, within just over half a century subsidence had rendered this building structurally unsafe, and by 1938 it had to be vacated, the Crown Court returning to the Great Hall, where it remained until 1974. The years 1965–74 saw the construction of a new, larger Law Courts – now extending all the way to Trafalgar Street – designed very much in the modernist mode by the Louis de Soissons Partnership, completed by Richard Fraser. Not perhaps to everyone's taste, but the combination of dark brick, glass (metal frame) windows, concrete and flint-facing, does at least reflect a late twentieth-century variation of the former castle, while giving onto a large (if still rather sterile) open amphitheatre-like public space. Architecturally, it probably still works better than the now rather 'twee' late Victorian mock-medieval buildings along Castle Avenue, or the complete architectural mismatch of the red brick and slate-tile buildings facing onto the High Street and Trafalgar Street. The weakest element is the actual physical link to the Great Hall; a missed opportunity. 'Less than perfect,' remarked architect Peter Kirby in 2002, suggesting a 'neutral and transparent device, linking the old with the new' would have better suited than the existing rather blank brick wall.

The Courts were opened on 22 February 1974 by Lord Hailsham of Marylebone (1907–2001, former Quinton Hogg, MP), then Lord High Chancellor.

Winchester Combined Court Centre, Castle Hill, *c.* 1988.

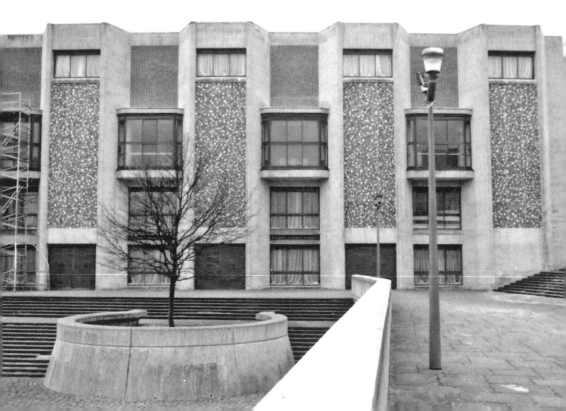

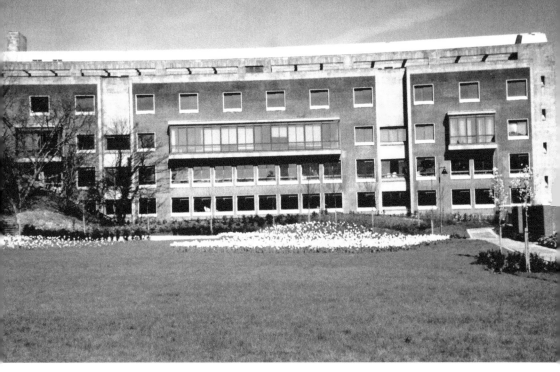

South side of the Combined Court in the 1990s. (This view is now obscured by trees.)

47. The Brooks Centre

Roman, and later Saxon Winchester extended from the high ground where the medieval castle later stood, and the Iron Age enclosure known as Oram's Arbour (to the west of the railway station), down across the Itchen valley to the steep slopes of St Giles' Hill opposite. It is likely the meandering streams of the river once flowed further westwards; about a series of tufa islands which the Romans later drained and levelled to became in part what is now the Brooks, with the main Itchen channel moved east to its present channel. However, with meandering floodplains to both the north (between Hyde and Winnall) and south (towards St Cross), tributary streams still bisected the city, continuing to flow down Lower, Middle and Upper Brook Streets as open ditches prone to flooding until the second half of the nineteenth century, before eventually being channelled into underground culverts. Because of this, from medieval times on, this was a crowded, working-class area of industry and manufacturing, especially cloth-makers and tanneries. Demolition and redevelopment of this locality began in 1953–54 with the widening of St George's Street, and continued apace through the 1950s, doing, in effect, what German bombs never did. The outcome was a multi-storey car park (now itself demolished), the usual bland concrete and glass 1960s shops and offices, the (at the time much-praised) Casson Block (by Sir Hugh Casson, 1962–63), and, belatedly, in 1991 the Brooks Shopping Centre – in retrospect the most interesting and architecturally innovative in design, if perhaps simply in the wrong place.

Designed by Manchester-based BDP Architects (formerly Building Design Partnership, founded in 1961) on a 2.5-acre rectangular site bounded by Middle and Upper Brook Streets, St George's Street and Friar's Gate to the north, this is perhaps at the time of writing the most vulnerable of our fifty buildings, being threatened with demolition in

Left: The Brooks Centre, viewed from St George's Street in the late 1990s.

Below: The Brooks Centre, viewed from Tanner Street.

The main atrium at the Brooks Centre.

2015, following its then owners, De Stefano Property Group, going into administration. When opened it comprised fifty-seven units, 112,500 sq. ft of retail space, and underground parking for 360 cars. The retail units (of which, until 2016, Bournemouth-based Beales department store was the flagship) mostly face inwards onto a three-floor central glazed atrium, with two main entrances on the south side, giving onto all three levels. A small museum was installed in the basement of Roman and medieval archaeological finds from the 1987–88 site excavations. While not without detractors, it would be a great pity if this modern building, with its delightful exterior tower (complete with 'carillon'-style cluster of bells and clever pyramid-shaped roof structure) were to be lost, and most likely replaced by something utterly unimaginative and bland. Sadly it has been hobbled by a combination of the growing trend for online shopping, together with high rent and often crippling business rates, plus a strange reluctance by the City Council to exploit perhaps a more Covent Garden-like retail/restaurant/leisure-cum-performance space usage. In 2015 it gained a reprieve when acquired by real estate firm Catalyst Capital, who have promised a multi-million pound revamp. Watch this space.

48. Winchester Cathedral Visitors' Centre

The first photograph shows the south-east corner of the Cathedral Yard, immediately opposite the West Front, sometime in the late 1980s, with the Hampshire and Isle of Wight War Memorial – a 28-feet-high octagonal shaft, surmounted by a cross. It is attributed to architect Herbert Baker (1862–46), who designed the War Cloister in Winchester College,

and was unveiled October 1921 by Major-General Seely MP, then Hampshire Lord Lieutenant. In addition to the rose of England, it has the lilies of France, and the coat of arms of Hampshire, the Isle of Wight, the City of Winchester and the Hampshire Regiment. Further inscriptions were added following the Second World War. In 1992 the Dean and Chapter commissioned the construction of a dedicated Visitors' Centre on what was then the overgrown garden of No. 11 Cathedral Close, originally the Priory kitchen gardens, with the book and gift shop and undercroft entrance being incorporated into the old seventeenth-century stables and carriage house. To the right of the entrance, in medieval times, was an ossuary (a charnel house). In addition to the bookshop/visitors' centre, the initial brief given to Winchester-based architects Plinke, Leaman & Browning (PLB) was a restaurant, toilet block, and later an education centre. Because of the site's virtually untouched archaeological potential it was decided to keep the building as lightweight as possible and 'float' the base slab using micro bored piles centred at regular intervals as support, while the A-frame triple roof shape was designed to allow as much sunlight as possible to filter through to the north-facing paved terrace area.

The first phase comprised the Refectory caféteria/restaurant and enclosed courtyard, and was opened on 19 November 1993 by Her Majesty the Queen. The Paul Woodhouse Suite, a venue for meetings or functions, was completed in 1998–99. A constant problem for both phases was the limited access to the site, originally less than 4 feet wide, so any large items had to lifted over the wall by crane. This was even more acute in the second phase, by which time the entrance was completely closed off and the Refectory in use, so it necessitated road closures for a weekend while the prefabricated building parts were again painstakingly lifted over the west perimeter wall, prior to being assembled.

Cathedral Close and the War Memorial around 1988, before the Visitors' Centre was built.

Above: Entrance to the Cathedral Visitors' Centre.

Below: Refectory Restaurant and courtyard at the Cathedral Visitors' Centre.

49. Hampshire Archives and Local History Centre

Until 1918 the corner of Sussex Street and Station Approach had been Saunders cycle shop, after which it became the Carfax Hotel (apparently named from the French *carrefours*, 'the meeting of roads'), with Sharps Temperance Hotel at Nos 1–2 until 1929 when the Carfax expanded its premises. The hotel closed in the early 1960s, and from 1966 until 1970 it was used by King Alfred's College as accommodation for forty-five students under a warden, before being finally demolished in 1972 when Sussex Street was widened. Fast-forward twenty years, and 17 March 1992 saw the laying of the foundation stone for the groundbreaking Hampshire Records Office by Lt-Col Sir James Scott, then Lord Lieutenant of Hampshire, and F. A. J. ('Freddie') Emery-Wallis (1927–2017), Conservative leader of the County Council 1999–2001, a man whose vision was sadly besmirched by scandal and disgrace. The design is accredited to Sir Colin Stansford Smith (1932–2013), County Architect 1974–92, and his Project Architect was Steve Clow, now Assistant Director of HHC Property Services. It is built on a slope and Stansford Smith certainly embraced more complex, site-specific designs, often centred onto courtyards or 'walled gardens', while he apparently likened the brick base to a 'casket'. Rosemary C. Dunhill was the County Archivist at that time.

The Twentieth Century Society (https://c20society.org.uk) describe it as 'brick-faced... [with] suggestions of a defensive city wall and castle keep, a striking contrast to a series of light, steel-framed, angular roofs and balconies overlooking an enclosed garden on the south-west side, with water channels and a sculpture by Glynn Williams.' It was opened by HRH the Queen and Duke of Edinburgh on 19 November 1993, replacing the previous County Records Office at the former church of St Thomas and St Clement in Southgate

The Hampshire County Records and Archives Office in Sussex Street.

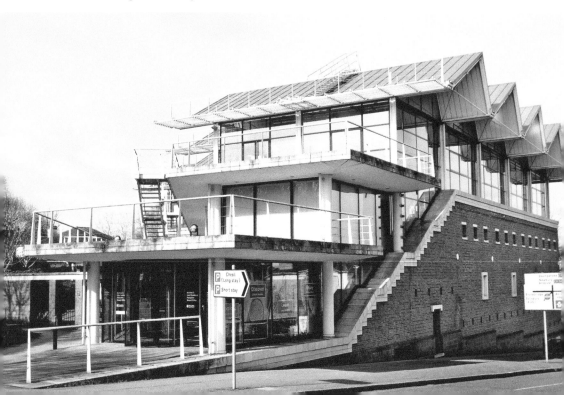

Street (from 1969 on, after the church was de-consecrated), and brings together the Winchester Bishopric and Cathedral Collections, City Archives, Wessex Film and Sound Archive, and family and estate papers, while being only one of two county record offices in the country designated as of national and international importance.

50. St Alphege and St Edburga Buildings, Winchester University

Although officially two separate buildings, they are uniquely adjoined with a shared piazza space and glazed atrium link to appear as one. This is still confusing for students today, who distinguish the older St Edburga (1969) by its tired brick exterior and green interior, and St Aphege (completed in 2012 by Design Engine) by its impressive glass framework and purple interior. St Edburga was the former Student Union and swimming pool before it was converted into offices for the Faculty of the Arts in 2008, whilst an extensive refurbishment took place above with modern lecture theatres added and sci-fi bridges attached during the construction of St Alphege. The building was renamed as St Edburga in 2008, after a daughter of Edward the Elder (King Alfred's son) and his third wife, Eadgifu of Kent, who at the age of three was given as an oblate to St Mary's Abbey in Winchester, the Nunnaminster founded by her grandmother, Queen Ealhswith. As a nun and a princess, stories appeared about her purity; her singing to her father, being thrashed by an abbess who did not realise her importance and who then begged for forgiveness, and the princess cleaning the shoes of her well-born companions, who were shocked and reported it as behaviour that was not right for her. After her death in 960 at the age of forty, a cult was formed in her memory, and she was canonised in AD 972.

The St Alphege building project began in 2010, cost £6.5 million and was officially opened by HRH the Earl of Wessex in 2013. It consists of eight state-of-the-art lecture theatres, a living wildflower roof, solar photovoltaic panels and acoustic panelling to reduce sound pollution; the building was awarded an 'excellent' rating for environmental

St Alphege and St Edburga Buildings, Winchester University campus.

The main entrance to St Alphege and St Edburga Buildings, Winchester University campus.

sustainability against the international standard (BREEAM) and the Regional Award for outstanding design in 2013. The metal framework sculpture on its frontage is intended to symbolise the twelve apostles, reflecting the religious connection of the University. St Alphege (also spelt Ælfheah, *c.* 953–1012), Bishop of Winchester (984–1006), later the Archbishop of Canterbury, negotiated peace with Viking Olaf Tryggvason and converted him to Christianity. However, shortly afterwards he was murdered by the Vikings during a drunken feast when he was 'pelted with bones and ox heads and one of them struck him with the back of an axe, so that he sunk down with the blow, and his holy blood fell on the ground'.

The creation of St Alphege and development of St Edburga reflects the continual growth of the University, which has now reached 8,000 students and counting.

Bibliography

Books

Ball, Alan W., *Winchester Illustrated: The City's Heritage in Prints & Drawings* (Halsgrove, 1999)

Barton, Anne-Louise, *Winchester Through Time* (Amberley Publishing, 2013)

Barton, J., *Winchester, Yesterday and Today* (Halsgrove, 1998)

Beaumont James, Tom, *Winchester: From Prehistory to the Present* (The History Press, reprinted 2009)

Beaumont James, Tom, *The University of Winchester: 175 Years of Values-Driven Higher Education* (Third Millennium Publishing, 2015)

Beaumont James, Tom and Roberts, Edward, *Winchester and Late Medieval Urban Development: From Palace to Pentice* (1985)

Beaumont James, Tom, *Winchester: A Pictorial History* (Phillimore, 1993)

Biddle, Martin and Clayre, Beatrice, *Winchester Castle and the Great Hall*, (Hampshire County Council, 1983)

Carpenter Turner, B., *Winchester* (P. Cave, 1980)

Dick-Read, A., *Winchester in Old Picture Postcards* (1993)

Graham, R. and Newberry, C., *Look Up! Winchester* (Look Up! Publications, 2010)

James, T. and Doughty, M., *King Alfred's College Winchester: A Pictorial Record* (Alan Sutton, 1991)

Kilby, Peter, *Winchester: An Architect's View* (WIT Press, 2002)

Legg, Penny, *Winchester: History You Can See* (The History Press, 2011)

Morris, Richard K., *The Buildings of Winchester* (Alan Sutton Publishing Ltd, 1994)

Rance, Adrian, *A Prospect of Winchester*: A Guide to the City Museum (Winchester City Museum, 1978)

Rose, M., *History of King Alfred's College, Winchester 1840–1980* (Phillimore, 1981)

Smith, M. and Bocchetta, V., *Hyde in Living Memory* (Hyde900, 2010)

Stevens, P. and Dine, D., *Winchester: Seen and Remembered* (Hampshire County Library, 1978)

Yates, Phil, *Time Gentlemen, Please! The Story of Winchester's Pubs, Breweries and Hotels Past and Present* (The City of Winchester Trust Ltd, 2007)

Websites

www.arthurlloyd.co.uk for the Theatre Royal
www.britainonline.co.uk
www.building4change.com

https://c20society.org.uk (the Twentieth Century Society)
www.chesilrectory.co.uk (the City of Winchester Trust website)
www.english-heritage.org.uk
https://janeaustensworld.wordpress.com
www.jsna.org (the Jane Austen Society of North America)
www.literarywinchester.co.uk
www.nationaltrust.org.uk
www.sotonopedia.wikidot.com
www.theatreroyalwinchester.co.uk
www.travelwessex.com
https://en.wikipedia.org
www.winchester-cathedral.org.uk